ASPECTS OF
SOMEWHERE ELSE

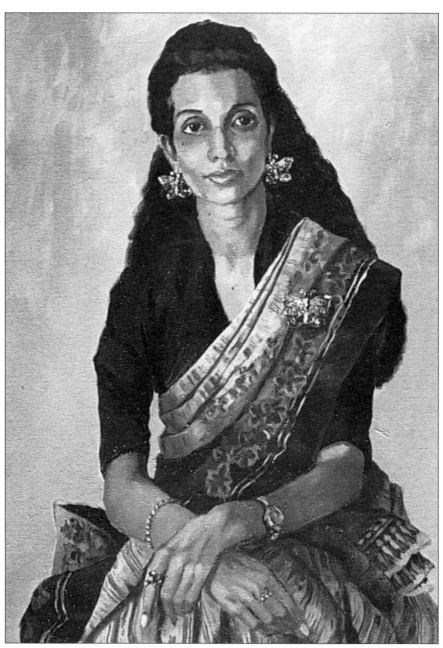

Yasmin, sold at an exhibition at the Air Gallery, Dover Street, London, March 1999.

ASPECTS OF
SOMEWHERE ELSE

ROSEMARY TROLLOPE

For Anne, with best wishes

Rosemary

SUTTON PUBLISHING

First published in 1999 by
Sutton Publishing Limited · Phoenix Mill
Thrupp · Stroud · Gloucestershire · GL5 2BU

British Library Cataloguing in Publication Data
A catalogue record for this book is available from the British
Library

ISBN 0 7509 2291 5

 ALAN SUTTON™ and SUTTON™ are the
trade marks of Sutton Publishing Limited

Typeset in 10/14 pt Sabon.
Typesetting and origination by
Sutton Publishing Limited.
Printed in Great Britain by
Redwood, Trowbridge, Wiltshire.

for
Louise, Paul and Maria

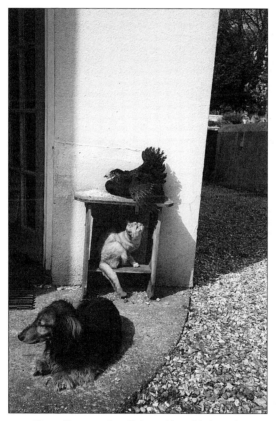

Henny-Penny on her dining table, with Artemis
sunbathing below and Roddie in front.

Contents

Acknowledgements

I am immensely grateful to Mary and Ian Crombie for all the varied and invaluable help they have given me during the making of this book. Also to Dr Alison M. Deveson and the services of Overton Public Library.

R.T.

Preface: How and Why

Because I am a painter I feel compelled to record all sorts of things that engage my attention, wherever I am, and by whatever means I have. Sometimes the means are words, and sometimes these can describe, at the end of the day, an event there was no chance to draw or paint at the time. This frequently occurs when I am in strange places and, with any luck, I will return home with a description of all I have experienced, contained in closely written exercise books, and on paper and canvas, and in sketch-books and the margins of newspapers, as well as all that is buzzing in my head.

Painting is not, of course, a sociable activity, but my husband Tony is endlessly forbearing, and judging by the amount of painting after family holidays, the children were pretty tolerant as well.

So it isn't difficult for me to call up, at will, Siena or St Petersburg, Singapore and Spain, Portugal and Peru, and Paris and Sydney, and Rio and the Scottish Highlands, and the great skies and formidable winds of East Anglia, to find out my first (and often fleeting) impressions, and the pleasures of the people we met, as well as a few nasty surprises. Like the earthquake in Perth, Australia: 6.5 on the Richter scale and as much a nasty surprise to the inhabitants as it was to me, as they didn't know they lived on a fault and needed insurance. Only a prudent few had taken out insurance after a small quake twenty years earlier.

I absolutely *hated* that earthquake, and from the moment we ran along the corridor of the large Victorian hotel in which we were staying, with the handsome arches overhead parting as we ran and showering us with plaster and dust, I couldn't stop shaking. Even the next day, still waiting for the second quake that

knowledgeable people assured us would come, I couldn't tell whether it was the earth shaking again or merely me.

That was a small enough event, but not paintable (though it might have relieved my feelings if I had painted the parting arches, or the handsome balustrade cascading off the tall building across the street, or indeed the huge wardrobe tottering across our bedroom, its doors swinging open helplessly). So it was as well that I wrote it down.

Or perhaps not. Just remembering it engenders the particularly horrid fright again, so I will turn to happier topics.

Gairloch

The density of the roads and places and names in any road atlas of the south of England is alarming. It would seem impossible to drive between green fields or woods (and I daresay that in a few years it will *be* impossible) anywhere near London, or to distinguish between one place and the next.

Living in the area, one realizes the maps are deceptive, but the maps relating to a great deal of Scotland are not. Calm maps, with very few red lines for roads, and even fewer place names, well scattered. Plenty of white or pale green pages in between, and though contour maps have more variation, there aren't many more places.

We gazed at the stretch of country running either side of Loch Maree in Wester Ross. No roads at all, save one running along the southern side, and only little twigs of lanes and footpaths mostly ending nowhere. That, we felt, was the map for us, and we set about finding a cottage to rent somewhere on that peaceful page for a summer holiday.

At that point our daughter Joanna was either engaged to David or almost, and as we had a capacious car which would hold six people he came with us (squashing in beside our other children, Andrew and Tory), and we put the car on the train as far as Perth. As all the passengers gathered at King's Cross one puzzle which had long bothered me was solved.

Wherever we had been on holiday as a family, either in Britain or abroad, we had very seldom seen families like us – worn-out M&S sweaters, improvised luggage, huge vital last-minute bags, and in Britain, the dogs. We saw smart, expensive families staying in smart, expensive hotels, as we saw families in special holiday clothes self-catering, and efficient camping families who had the whole thing buttoned up. But where were our clones? There were

plenty about, as we well knew, but never where we were. The train-ferry to Scotland answered this query. They were all on the train, and probably were every year, which is why we hadn't seen them in Cornwall or East Anglia or Portugal or France. They all milled about on the platform; and, fortunately, I knew our children's parkas otherwise I might well have collected someone else's young as we found our reserved seats. Most of the other dogs there were flat coats, but dachshunds, like our dog, Martina, are far more convenient in both car and sleeping compartment. She cast a smug glance at the nearest labrador being herded into the guard's van, as we bundled her swiftly into our compartment where she then sensibly became invisible.

I remember a rather hilarious and bibulous picnic in our compartment as darkness fell, after which David and Andrew retired to the one next door, and we heard no more of them until dawn, and shouts of 'Och ay, Pairth!' came through the wall. Soon afterwards, sustained by the famous station breakfast at Perth, we set forth for Gairloch.

Tony and I, our three children, and David and Martina all fitted well enough into our rather stately car, a splendid second-hand buy recently acquired from its genuine previous owner, a careful elderly lady (a friend of my parents, so we knew she existed). The boot was hard put to cope, with kit for six, climbing boots, picnic things and all the rest of it, and I had had to be *extremely* modest in my painting materials, but we sailed along happily, enjoying the car's space and its giant headlights and its solid reassurance, until there was a sinister sound from the engine and it died at Kingussie. The big end had gone – whatever that was. It was serious, anyway, but had we been driving a Ford or Austin we might have been on our way again in twenty-four hours. But we weren't, and the big end for our car had to be brought to Inverness, and then fetched from there, and fitted, which was going to take about three days in total.

It was no good despairing. After one dreary night at a large chilly hotel we moved across the road to the cosy and welcoming Royal, where we found we were surrounded by the McEwan clan,

who were holding their clan gathering at nearby Newtonmore. Sharing our dinner table was the McEwan of Ealing, gloriously clad. Even his diary was tartan, although he said remorsefully that the shop had had no McEwan and he had had to buy Cameron. Never mind, all the rest of him was as McEwan as he could be, even if his kilt was a good 2 inches too long. (Someone should have told him it must clear the floor when one kneels.) His wife, he said, found clan gatherings boring, so he had left her with friends in Glasgow, shopping.

All the contents of the closely packed car had to be tipped out on to our bedroom floor before the car could be towed away, but we burrowed among it all, and found our climbing boots and weather clothes, and set forth to climb the nearby hills in a bitter wind. We didn't envy at all the pinched and hunched figures of pony trekkers who passed us in the glen – one had to keep moving briskly to keep warm at all. Reassuringly, David's tough new shoes worked and kept his feet dry. We did not then realize how seldom any of our feet would be dry during the next two weeks.

When the car was restored to us (the only time it let us down; I expect it thought once was was enough . . .), we journeyed on towards Gairloch.

The only cottage we had been able to find also contained the owner, Miss McDonald: she would do the cooking if we bought the supplies. This was the regime throughout my own childhood holidays in Cornwall, so I thought it would work as well now as it had then, and the cottage sounded just what we wanted – 3 miles out of the village, all by itself overlooking the sea. As we neared our destination we drove, for miles and miles, on single-track roads with passing places, which was not much of a disadvantage as we met very few cars. Following Miss MacDonald's rather hazy instructions, we came at last to the point where she had written, 'lane to left by big rock, "Sea View" at bottom'.

There certainly wasn't much competition, lane-wise, though there were plenty of rocks, but we turned down the little lane and 'Sea View' came into sight: an ugly little pebble-dash house

standing defiantly on the headland against the wind, with a glass storm-porch applied to its modest face. Inside the storm-porch sat two elderly people reading *The Times*.

It had never entered our heads that Miss MacDonald's 'cottage' would have room for more than the six of us. As we filed past them in endless procession, unloading the car, passing groceries over to the tall stern Miss MacDonald, apologizing to our fellow guests as we let in the wind and tripped over their feet, they looked as dubious about us as we felt about them. What would be the point of being miles from anywhere if we were not free to do as we liked? Tory was nearly fourteen, Andrew sixteen, David and Joanna twenty; all were high-spirited and clowned around and made a lot of noise, and my heart sank at the idea of constantly having to remind them to be quiet and behave themselves.

So it was with rather low spirits that we unpacked and stowed away our belongings as best we could, and went downstairs clutching our bottles of pre-dinner drinks. Our fellow guests were still in the little storm-porch and, small as it was, we crammed in there too because it provided a welcome glimpse of evening sun, and the little sitting room was dark and gloomy. Besides, we thought we had better introduce ourselves.

The other couple politely offered us some of the gin they were drinking and as politely we demonstrated that we had our own supplies. They said their names were Hugh and Nancy Lyon and, as we made stilted conversation, mentioned that they had lived in Rugby.

'You're the headmaster!' said Andrew.

'Was,' said Hugh. 'I've just retired.'

'And you wrote that smashing book of poetry,' said Andrew. Hugh beamed at him and from that moment on we were all friends.

They were *so* nice, interesting and well read and, being used to boys, never minded the noise or horseplay. And even Miss MacDonald unbent in due course. She had a joke that she was happy to use every morning, knocking on Andrew's door, which

opened off the dining room, saying, 'Andrew, your porridge is getting cold!' Andrew was not at all enthusiastic about porridge, hot or cold, and was teased about it, so daily Miss MacDonald found this funny.

Hugh had a better idea when it came to getting the equally tardy David out of bed. He banged on David's door and shouted, 'Quick, David, Joanna's gone!'

It rained – thoroughly and steadily – every day except three, and the only disadvantage to being in the same house as the Lyons was that the hot water was very limited and we had to make sure they had it first. The drying place for boots, by the tiny boiler, was equally limited, so that in all the time we were there I counted myself lucky if I had at least dry socks to insert into my wet boots.

David, a brilliant sportsman, with junior county tennis championships behind him and various blues ahead of him, had never previously climbed a mountain. Tony is a forbearing guide (which he has to be with me in tow, because though I am quite happy going up mountains, I suffer acute vertigo coming down and see double, feel giddy and wish myself anywhere but there) and David enjoyed himself, although the energy needed is clearly a different kind from that used on the squash court, and he was exhausted before any of us on hill walks if they went on too long.

At the bottom of one mountainside they were all waiting patiently for me as I slithered down, feeling extremely sick, with only Tory, ever considerate, lingering anxiously nearby. When I rejoined them David peered at me and said, 'Good God. I have heard of people turning green but I thought it was just a figure of speech.'

We walked for miles on glorious unsullied beaches by a clear unsullied sea. The boys tried to bathe but could only manage half a second; just putting one's finger in was enough to atrophy one's whole body with the shock of the cold. There is a photograph captioned 'Tory took off her sweater just to show she could'.

One day we went to Torridon and walked about 8 miles and climbed about 2,000 feet and Martina, the dachshund, was still

full of energy when we reached home again. If one wasn't going to Torridon it meant the long, long road alongside long, long Loch Maree, which led to everywhere else, and we became very well used to it.

On the wettest day of all (which was saying something) we walked from Eileann Darach, and dug out a ferryman and his wee boat, and he took us across to Ullapool, which was most attractive. In the schoolyard the children were playing, all buttoned up against the rain, which they ignored, and we lingered listening to their singing Highland voices, every consonant defined. Two little girls near the fence were deep in conversation, and then one broke away, saying, firmly, 'Och, I'll leaf all *that* till I am marrit'! As she must have been about six – her front teeth were missing – it would be some time before she was 'marrit', but I felt sure she would make an excellent wife for some lucky boy in due course!

Another day the three boys set out to climb Beuss Beinn (3,012 feet) and came back full of joy saying it had been *hot* on the top. Meanwhile the three of us girls – four if one counts Martina – took advantage of one of the only three fine days and spent it on the beach, walking home through the pass, with not a drop of rain all day. We even found a crevice that was sheltered from the wind, where we could read for a bit after we had eaten our lunch-time sandwiches, and tried earnestly to detect some holiday tan on our faces and hands.

The remote and deserted countryside was very beautiful but also a bit depressing. Whenever one came upon a lonely croft the roof had fallen in, and whenever one saw a boat it was rotting on the shore. One knew, of course, all the reasons, and thirty-five years ago the inhabitants hadn't yet awakened to the fact that a form of salvation was at hand in tourism.

I don't know what it is like now. One shudders at the thought of how destructive tourism can be, but there is no denying it has brought 'mod cons' and employment to many dying places. And if we, as holiday-makers, find it rather fun to have intermittent

electricity and to have to throw the rubbish in the burn at the back of the house (where the weather and the sea and rocks took care of most of it), as Miss MacDonald did because there was no refuse collection and the headland was too wet and windy for bonfires, it is all very well for us, returning to places where the utilities are taken care of. We saw a considerable number of completely burned-out houses on our travels because, of course, it takes the fire service so long to get there, if it does at all.

By the same token, and for the same reasons, we were not in luck if we wanted a warming cup of coffee when we came to a village or – heaven help us – some bread to help out our picnic lunch. The leitmotif of the holiday in my mind is a banged door and a firm 'We're closed!' There were few exceptions. It was very hard for me to demonstrate to our Sassenach children that Scottish bakers are the best in the world. Never mind Vienna; the Scots are in a class of their own, even if, until recently, baking was all they *could* do in the kitchen. This, of course, was because of the paucity of materials in the old days, so that women, tired of boiling neeps and potatoes, and in many cases unable to afford the excellent meat and being too far from the coast for fish, turned to baking and became superb at it. During our Gairloch holiday, however, it was hard to find a baker at all, never mind often, and mostly our lunches depended on all-too-familiar factory made sliced bread, stale because it took so long to reach there. This was a pity, because the children had to wait until they returned to Scotland, much later, to discover that what I had said was true, and that Scottish baking is brilliant.

The whole of Wester Ross is scattered with mini lochs and ponds, which sometimes make a route difficult unless one is a corbie, and there is also the complication of ferocious fencing around private estates. Trudging round these, going miles out of our way, I wondered resentfully about the absentee landlords. American syndicates? Oil princes? Pop stars? Whoever they were, they and their 'friends' came very seldom, as we were told on every hand, and at every estate.

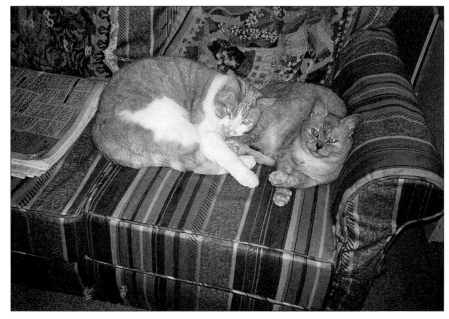

Waiting for us at home, Romulus and Artemis.

Even so, wandering through this empty countryside was very refreshing. A man I met once in Sri Lanka said he could never live in England again, no matter how much space there was, because 'There is always a village over the next hill.' He should have tried Scotland. Around us in Wester Ross, at least, there were many hills to climb before there was a house, never mind a village.

We left 'Sea View' and Miss MacDonald with regret. But 'think of her', said Andrew as we drove away, 'on a stormy winter's night. She has to go down to the burn to hurl in the potato peelings because if she leaves them in the kitchen overnight it encourages the rats.'

As we made our way homewards I began to think longingly of a deep hot bath, and dry shoes, and fresh green vegetables. 'And the darling cats,' said Tory, reading my thoughts. Painting, of course, had not been physically possible. Both in the storm-porch at 'Sea View' and in the car, which were the only shelters from the rain, it

was too cramped to move one's hands, never mind set out even the most modest of watercolours. All I could do was draw people in the evenings, by the gentle lamplight, as we read or talked or played paper games, so it was also going to be good to get back to the studio, and indulge myself, even if only I can find all I want in the chaos there.

Paris

We tried to celebrate each of our children's twenty-first birthdays exactly as they wanted. Andrew chose, with no hesitation at all, to celebrate it in a smart London club but (since this was 1969) he kindly allowed his parents, and even a selected godparent or two, to be there. It was very good fun and the adults could retreat from the racket, when dinner was over, and let them all get on with it.

Tory also knew just what she wanted in her turn. Dinner and dancing at home for her best friends. Our house is not large but this sounded perfectly possible if we could find a really good group to provide the music and if – since we live in the village – Tory went round all our neighbours first to warn them. I asked for a list of those to invite and within moments she had produced one with 120 names on it. She wanted proper dinner, she said, not people sitting on the stairs with a plate and a glass, so I had to ask her to cut the list down a bit. Just a bit. She extracted, with much groaning and tribulation, twenty people, and we settled for a small marquee to dine in, and dancing in the hall and dining room.

Joanna and I cooked the feast and the dinner tables looked splendid. A small factory nearby, which made dressing-gowns for M&S, had yards and yards of royal purple fabric for sale at a knock-down price (which wasn't surprising – it would have made formidable dressing-gowns) and this made our tablecloths. With white china, orange, yellow and white flowers, and lots of candles, it all looked very festive, and so did the house as it (and the village) quaked with the beat. But we have good neighbours. Not one word of complaint from them, and many must have had a very disturbed night, to put it mildly.

During the evening I overheard a conversation I particularly enjoyed. A voice said, 'Which one is Tory's brother?', and someone

10

replied, 'He's the tall one in green velvet trousers.' 'Oh,' said the first voice, 'I thought that was her mother.' 'Well yes,' said the second voice, 'but he's a lot bigger.'

Joanna's twenty-first came way ahead of these events, however, in 1965. She was almost through Oxford and engaged to be married. She didn't want a party, she said, but a weekend away, all of us together. Not her beloved as well? (We were by now accustomed to David and delighted to have him added on.) 'No, only us.' She was firm about it. It was only later that I realized what she knew then, that this would mark the end of our family as a unit. First she, and then the others, would go on to make new relationships, and lead unknown lives and, eventually, have new families of their own with their own children. Most families come to this more gradually, with adolescent children holidaying elsewhere, and eagerly breaking away, but ours had done little of that. Instead their friends had attached themselves to us, and very welcome they were; also entertaining, like the young men with a tiny tent who followed us to the south of France in Joanna's first long vac, in order to quarrel over her. The tent was so small that they could vent their temper on that, and every morning they did, while each had one eye on his golden object and the other, warily, on his rival.

We began to discuss possible venues for Joanna's long weekend, as we had decided, even with the usual tight, tight budget, that we could have four days. 'York' someone said, or 'Canterbury?'

'No' Tony said firmly, 'we'll do it properly. We'll go to Paris', and so we did.

Joanna had been briefly in Paris during her French exchange summer, but went to school with her swap, and then they had all decamped to the family house in the country, so she hadn't seen much of the city. Andrew's swap had been spent entirely in the south and Tory, who was fourteen at this time, still had hers to come.

So we could do all the conventional Paris things and it would be new to them, and however familiar they later became with Notre-

Dame and the Place des Vosges, one's first sight and first impression are all important.

All our friends recommended good cheap hotels, and we booked one (we thought) near the Opera. It was only when we found ourselves being decanted on the Left Bank in the Rue Gay-Lussac, near the Sorbonne, that we realized we had chosen, instead, the Hotel Gay-Lussac.

It looked a dreary place. We crowded into the tiny reception area and rang the bell, as instructed, on the desk. After a while an unsmiling woman appeared. Tony had by now fished among his papers and had proof that we were booked in, and she reluctantly agreed, and led the way up interminable and rickety stairs. The worn stair carpet soon ran out and we continued on up on slippery threadbare matting, arriving at long last in some rooms straight out of Frances Hodgson Burnett's *The Little Princess* – bleak, ill-lit, sparse and chill. We all said, 'Oh no, this won't do', but the maid had scarpered, vanishing on her felt-slippered feet before we could speak.

So down Tony went, all that long journey, and came back saying he had sent for the patron, who duly appeared, clearly and irritably having been interrupted while eating. He had the sense to look at us, however, before he spoke – even if, puffing and blowing as he was, he had been able to speak. Tony can be very obdurate and was looking it. The patron's eye then met mine and found no comfort. He then looked at our tall blonde daughters with appreciation, albeit nervous appreciation, and lastly at the even taller blond Andrew who was gazing down at him with undisguised contempt. Oh what a mistake! How could the stupid maid have shown us to the wrong rooms? How absurd! 'Please come this way. Please accept the most profuse apologies – these rooms are only for the students.' We all trooped after him, past several floors, and were shown into very different rooms. Ours was large, with long windows opening on to the busy street, and perfectly adequate in a rather peculiar way, but the children had an even stranger room. Again large, it gave the impression of being

E-shaped, the beds tucked into alcoves, and their bathroom was substantial and triangular, with bath, basin, bidet and shower all scattered about so that they could all wash and bathe at once if they wanted to. The rooms were clean, though in need of paint, and had fresh blue-white sheets on reasonable beds, so it served us very well in spite of not being near a Métro. It was, however, just off the 'Boule Miche' which teemed with student life, and Joanna loved the comparison with Oxford, and watched avidly as much as she could.

It didn't take us long to be unpacked and out to begin on Paris. It was a lovely evening and at one point we sat having a drink and watching the sun go down in flames behind the Eiffel Tower,

casting vermilion chips into the coffee-coloured water of the river. Then walking through the Place de la Concorde and up the Champs-Elysées we saw Paris at its best, in the half-light, all the lights just coming on, glowing gently. We dined well and late and walked miles and miles – the children couldn't get over how much space there was, even on pavements half-filled with tables, and it was an extremely satisfying evening.

Tony and I could hear a good deal of hilarity coming from next door as we prepared for bed, and then abrupt silence. Next day we were told that the girls had been in bed well ahead of Andrew, and had settled down with their respective books to have a nice long read. Andrew had then emerged from the bathroom and announced, 'I am God and tomorrow is the Day of Judgement so I have to make an early start' and firmly turned out all the lights.

It had been a long day . . . I daresay God was being quite sensible. Especially as He had begun it by being unable to find His mackintosh when Tony was already fuming at the wheel, late in starting for the airport. 'I've *looked* everywhere,' He said, standing mutinously in the hall. Joanna found it in His bedroom, but needn't have troubled as He left it behind in the airport a few hours later.

We accomplished such a lot in Paris that we might have been tourists of the 'If this is Paris, it must be Tuesday' type. We even went to Versailles, but found it closed for a visit by the Danish royal family. However, the children were delighted by the peaceful regularity of the gardens, and the conical Mr Noah yew trees and the statues, scattered with such a lavish hand down the vistas, as were the marble seats. When we paused at a café in the Bois for a drink, a beige-striped cat at once leaped on to Tory's knee and settled down, pushing its face lovingly against her sweater. She showed us the present she had brought for Laurie, her own beloved cat at home – a pin-up of a pretty fluffy French ginger-puss.

A letter came from my mother, whose letters reached me without fail wherever I was. This one began in French – '*Mes*

*pensées suivant toujours (ventre à terre parce que vos jambes sont
si longs et vous marche si vite, si vite . . .)'* – which I much enjoyed.

When we went to the Palais Royale it was bathed in late
sunshine and there were only a few people about. It was very
quiet. It felt as though the beautiful romantic Palais was ours as we
sat on the edge of the round pond where the Sun King sailed his
boats as a boy. He never knew it quiet and peaceful as it was for
us, nor, later, did poor Marie Antoinette or, later still, the eighteen-
year-old Napoleon, losing his innocence to a middle-aged whore
under the arches.

I drew the children as they talked and laughed, mourning that I
had no paints with me. Their exuberant fair hair and bright
colouring made them stand out wherever we went, but most of all
against a foreign background. This fact has had its uses. A few
years later, we drove a long, long way to Herculaneum, and arrived
just as the attendant was closing the gates for siesta; we were in
despair. He was adamant: we could come back at 5 o'clock. Which,
of course, we couldn't, as we had to get back to Castelabatte that
night. So, just as he turned the giant key, we edged the girls
forward. The sight of two beautiful blondes was too much for him
and the key never made its final turn. We could come in, but the
gate would then be locked while he had his siesta, if we didn't mind
having Herculaneum to ourselves for the afternoon.

Few people are ever so privileged. It was one of the highlights of
my life, and reached its peak when I walked, barefoot, across the
mosaic floor of the Women's Bath where other bare feet had
walked so long ago.

When we left the Palais Royale we walked in the Les Halles
direction, aiming for St Eustache; Les Halles was just about to be
pulled down and redeveloped, so we walked through narrow streets
in a state of dramatic decay. In the fading light the colours were
gentle, grey and cream and dusky dark shades, with even the few
lights from open upper windows, where silent watchers monitored
our progress, looking like no more than candles. Which is probably
what they were.

15

It was amazing that these derelict houses, lop-sided from subsidence, and many of the windows boarded up, just glimmers of light showing round the edges, were inhabited but they all were. But there was no life outside. Not even a cat disturbed the deserted streets, which made them all the more theatrical. I was reminded of a thesis written by a young friend for her A-level, on the beauty of decay, well illustrated with examples from a decrepit Welsh house and garden.

Joanna saw this as we traversed these streets, and the light now and then caught the glint of a watching eye at a window, ragged curtains blowing in the breeze, and she adored the walk. Tory thought it 'very interesting and absolutely horrible', while Andrew could hardly bear it at all. He saw nothing but the appalling degradation of having to live in those conditions, even for the short time before all these streets were swept away.

The other area sorely in need of repair in 1965 was the Place des Vosges, perfect and complete since 1630, but unlikely, as Tony remarked, to remain so unless someone mended it pretty smartly. (Fortunately for later visitors, this was done.) A visit there, and feasting our eyes on the rose-pink and grey of the absolutely satisfying buildings, soothed Andrew's feelings, still bruised from the death-in-life streets we had walked the day before. Some boys from the local school were playing noisy football in the square, and constantly kicked the ball over us into the traffic as we sat having a drink at a corner café. And, as constantly, Andrew dived heedlessly after the ball into the traffic stream, and kicked it back.

We shouldn't have paused, in passing, at the Bird Market because Tory worried all the rest of the day about the birds in tiny cages with, very likely, an even worse home ahead of them. There is such charm (if one can harden one's heart as she couldn't) about the minuscule beige and turquoise birds called Bengali Cordon Blue, huddled together head under wing, in heaps, and others, equally small, the size of cotton reels, magenta ones, green ones, gold and scarlet all in the same cage. All flitting and twittering and twitching, and the air full of their tiny mad chatter.

When we were in St Chapelle, Andrew observed that if the colours were as wonderful as they were, what would it be like if anyone had ever cleaned the windows? Which was true enough. I looked when we went outside again and the windows were obscured under a heavy layer of charcoal dirt.

We ate extremely well on our travels, wherever we happened to be, and in a small café where we had lunch one day there was a man, just inside the door, reading a comic and eating snails. Our own lunch, at the other side of the room, was somewhat delayed because the waitress was attending to a very demanding party seated just behind us. Two sets of parents and a grandmother were having a strenuous time trying to keep a convivial atmosphere going, because the boy and girl with them, aged about twenty, seemed to take a marked exception to any such effort. They sat beside each other and never spoke a word. They took no part in the loud and long discussions about food, and turned their heads away in disgust when, the dishes having at last arrived, their parents passed experimental fork-fulls to each other. It was extremely diverting to watch, as was the subterranean exasperation of both mothers who would clearly each have a good deal to say to their tiresome children on the way home. If this was a 'marriage arrangé' it had a long way to go, and Joanna, carefully not showing any expression and keeping hilarity at bay, was drinking in every self-conscious word and noting every careful glance as the parents strove to keep it going.

As we left, more than an hour later, the man by the door was still eating snails. The waitress had just brought him plate after plate after plate non-stop. Maybe he is still there.

I am glad it rained for a bit one day (even if Andrew got wet, as of course he did), otherwise I would never have known about the delicacy of the French head. The shower came when we were walking along the Boule Miche, the Sorbonne undergraduates swarming round us, and everyone immediately tried to protect their heads. Boys held open books over their heads, or plastic bags, and girls put folded sweaters or cardigans on theirs, and a baby in its

pushchair wore a yellow plastic bucket, and women out shopping tipped all their goods into one bag and donned the bag from the greengrocers, or the patisserie. It was all most odd. They didn't seem to mind the rest of themselves getting wet just so long as their frail and precious heads remained dry. We, of course, were dry – save one, who dried out eventually – and our damp hair soon recovered, as we couldn't be bothered with umbrellas as well as coats. But it was an education to see such different priorities at work.

On Sunday deep sonorous bells tolled over a grey, but dry city. The volume of traffic in the street below was halved, which wasn't saying much. The fruit stall on the corner, with its neat pyramids of oranges and lemons, was closed, and nobody sat at the bistro opposite our hotel.

The fruit stall had opened, however, when we emerged about an hour later en route to Notre-Dame, and people were going past with bulging bags, carrying home goodies from the delicatessen round the corner for Sunday lunch.

In Notre-Dame, amid the singing and chattering crowds, Mass was just finishing. We inspected the rose windows and climbed a thousand spiral steps on to the roof, and looked down on a grey Paris spread out like a map, with a café-au-lait Seine curving through it. Looking straight down on a miniature gendarme in the square below was too much for me, but Andrew went even higher, on to the parapet of one of the towers.

The sky was blue again when we climbed up to Sacré Coeur, fortunately, and the building shone against the sky, pretty and ridiculous as ever. We wouldn't have gone in, remembering the inside was pitch dark with nothing to see anyway, but we needed to get out of the sun to change the film in my camera. So when a priest walked past us Tony appeared to be reverently bent in prayer, but was in fact trying to catch a glint of light from a candle-lit shrine to see what he was doing. Andrew paid a franc to get up on the roof. Nobody wished to join him in the venture which, our guidebook said, could be guaranteed to give anyone vertigo. He said it was fabulous.

We sought lunch via a swift skirmish round La Place du Tertre, *filled* with tourists. The tables in the centre were taken by Germans, Americans and provincial French (this being the season for the last), and all round them self-consciously artistic artists painted quick bad sketches of execrable local scenes and tourists snapped cameras like castanets. We were glad not to linger, and to find a most delightful café offering four courses and wine for 12 francs, which we all felt was just the job for our last lunch.

It didn't matter that we had to share a table with two carefully Sunday-dressed French ladies, because they were a pleasure in themselves, and before lunch was over, our dear friends. They only wanted a little tomato salad, they told the pretty waitress with eyelashes like little hedges. 'But mesdames,' she said in dismay, 'that is no lunch. Allow me to mix you a little salad with some *good* in it.' They agreed to this without much trouble, and exclaiming in delight when it came, were soon persuaded to have a little trout, and then a little *tournado garnie*, and when we left were selecting cheeses, and looking forward to the *créme brulée* they had watched us eat so avidly.

They seemed very happy. They were two friends who left their families and lunched together on Sundays and they had done so for years. They chatted with the children, and murmured, 'Oxford, eh . . .' to each other with round eyes. They asked Joanna what she would do when she left Oxford – would she be a secretary, perhaps? Joanna said she was not sure what she would do but, she finished with a wide smile, 'I'm not going to be a secretary. I'm going to *have* a secretary.' (And so she did, in due course.)

We took our affectionate leave of the ladies, who gaily teased Tory – '*Voilà sa petite mignonne de Maman!*' – when she put her arms round my neck as we set off down the endless steps from Montmartre to the hotel.

Reading my notes now, remembering one dinner when I looked across the pink-lit table at the children we had been so lucky to be given, I marvel at my own perspicacity.

I remarked on how lightly Joanna wore her cleverness, and how vivid were her powers of enjoyment. I agonized over her future

encounters with the hard cold world, against which neither we nor anyone could protect her; she must – as we all do – learn alone, although she was more vulnerable than most in spite of her golden ambience.

The phrase 'New Man', with all its implications of hoovering and nappy-changing, had not been invented, but I wrote that Andrew, sitting there looking so elegant in his scarlet-lined grey jacket, was being most conscientiously 'Modern Man', albeit with persistently old-fashioned qualities, such as an endearing respect and gallantry towards women, beginning with his own sisters. And Tory – quick-witted, ironical, sceptical, self-mocking Tory – whose reactions and deep affections I so well understood. . . . They were twenty-one, sixteen and fourteen respectively, and thirty-odd years on I wouldn't retract a word of that.

The Alfa Romeo: 1973

In all the long list of cars we have had, we have only twice had the excitement of buying a new one, lingering over the choice of every detail, and having it arrive with its new smell, and all sorts of little vagaries connected with birth to be discovered, and either endured or put right. A traumatic business, if in both cases finally rewarding, but the second time the route to the new car was not one we would ever wish to repeat.

The children had all flown the nest, and Tony and I decided to take the car across the Channel and drive through France, Switzerland and Italy, and home via my sister and brother-in-law, who were living near St Tropez. Only, as another car was overdue, we would do it in a new one and, moreover, we slowly realized it need no longer be a sensible car able to take five people at least in the most economical way possible. As we had had good service from our present Triumph, we were easily seduced by the Triumph Stag, then new and most exciting. Having done with practicality, the idea of an open car was very appealing – that is, open if one took the top off, as far as I remember, and I don't know what one was supposed to do with the large solid top once removed. Certainly it doesn't sound much of an option if one is touring, but we didn't think of that. And in the event, we never had the chance to find out.

The Stag (we had chosen a daffodil yellow one; I cannot now imagine why – middle-aged rebellion can sometimes go too far) was promised for the beginning of March, so we booked it across the Channel at the end of May.

I was very much looking forward to practising a different kind of car along familiar roads before venturing to drive on the right-hand side. Our calls to the smooth, smart showroom became

increasingly anxious as March passed and there was no sign of the car. They had begun with 'wrong colour delivered' but that was early March so we had no difficulty in saying we didn't want a plum-coloured car. As April also sped by the pleasure of anticipating the holiday was much dimmed by our struggles to get some sense out of the car dealer. Finally we were at the day before our departure, when they rang up. 'Good news!' they said cheerily. 'Your car will be with us next Thursday for sure!' They knew very well the date of our departure. It should have been graven on their hearts, given the number of times we had told them.

Tony told them exactly what they could do with the car next Thursday, or any time, and said he didn't want to hear another word, from them or anybody, about Triumph. So we were left contemplating this long-awaited holiday in the old car, with its dodgy clutch and leaking roof and all too familiar lack of enthusiasm.

Tony still thought we'd be able to think of something, and in order to do so suggested that we should go and have a drink at the White Hart, at the other end of our village street. To our surprise it was crammed. Mostly men coming and going, bright-eyed, to the courtyard at the back where, we soon discovered, there was an Alfa Romeo demonstration going on.

We watched, mournfully. We were not in the mood to think about new cars, especially those out of our league. Soon, however, everyone knew our sad tale, and the salesman came and told us we'd be glad in the end because the Stag had some serious disadvantages, not yet worked out. We tried to believe him. He asked what we would now be travelling in and we told him, and he said, 'That won't be much fun'. We didn't need him to tell us. 'Why not take this demonstration car?' he offered, and we said that we couldn't afford it and anyway we were going in twenty hours. From the forms we had already filled in for the Stag we had learned that buying a car takes *ages*, even if it is delivered on time.

The salesman retired into a corner for a few minutes and came back with a set of figures, proving we could, after all, afford the

demonstration Alfa. Stunned, we enquired about all the paper work. 'I can do it,' he said. 'I can bring the car for you to try out tomorrow – you could take it now only some of these chaps need to see more of it – and if you like it, I will bring it to you by 3.30. I believe you said you were going at 5?'

Which is exactly what happened. I couldn't take it in, this long, low, dream of a car, with all its wonderful extras. The young salesman restored our faith in mankind, so battered by two months of wrestling with the Triumph dealers, and it was a long time before, glancing at the elegant crimson car in a car park, I could take in that it was really ours.

We had to rethink our luggage a bit. The Stag had a very large boot and for once – because normally we travel light – it had not been necessary to keep on cutting down. This was great luxury when it came to my painting kit. I could take oils – heavy, messy oils – safe in the knowledge that there would be space to bring home the paintings spread out on the back seat if they were not yet dry. We also packed giant bathing towels and even more books than usual, which is saying something. (Small boys on Greek island quays soon learned, when leaping forward to carry our two flight-bags and one small case, not to try and lift the last as it seemed to be full of concrete. Only books, of course, but even paperbacks weigh a lot if you have enough of them.)

The Alfa had a fairly reasonable boot and a very small back seat, so we managed to cram in the bags and cases which looked very beaten-up and shabby by comparison, at the last moment I fetched a plastic sheet from the shed, terrified that I would sully the inside of the exquisite car with wet paint. It was the first – and almost the last, now I come to think of it – time that I ever considered the inside of a car, though I say it to my shame.

Just before we left Andrew thoughtfully rang from London, partly to say 'Bon Voyage', but mostly to ask whether we had remembered the car compass, which was on top of the Wellington chest in the study. Of course we hadn't. Then we were off (vroom, vroom), two suitcases in the delicate little boot, painting kit,

bathing kit and a bag of guidebooks and maps in the back, our astonished selves in the front, to the Southampton ferry.

We were very polite about 'You drive', 'No, *you* drive' on the way to Southampton, both of us yearning to, but we had a great deal of driving ahead of us, so we *almost* had our fill. (Not quite, because for all the years we had that lovely car it was always a pleasure to drive. We only sold it because it would never start on winter mornings – craving its native sun, I suppose – and in those days every Alfa Romeo should, really, have been sold with its own mechanic as part of the fittings.)

From our new and unfamiliar stature, I watched with delight our fellows in the car queue. Bulging cars towing caravans, two stout, brisk, jolly, white-haired ladies in a Morris 1000, a young couple with a little daughter, and quite a few people of whom one could only think 'How *do* they do it? And whatever will they do when they get there, wherever it is that they are going?' Worst of all was a lone stout man in a little red MG. 'Do we look like that? Wish fulfilment come too late?' I asked anxiously, and Tony said firmly that of course we didn't: 'We never wasted time on this wish, did we?' Of course we hadn't. Not for a moment. Which didn't make it less entrancing when it came.

We were quite used to being noticeable because our children were (with their bright colouring and spectacular hair), but that was *nothing* like travelling with the Alfa Romeo. Even in Switzerland, before we crossed the border into the car's native land, where everyone took a nationalistic pride in it as they though they had a personal input. Our GTV was then a new model, and though large compared to the lone man's MG, it was a small car by most standards.

On the ferry a young couple and their three-year-old daughter settled themselves next to us in the restaurant, and I admired their calm as Julia – blonde, sweet, adamant and over-tired as they had left home at dawn – threw a tantrum. She wanted crisps before lunch and they said she could have all she liked *after* lunch, so she set herself to sulk. When this didn't work she began to grizzle, and

then to wail. Her father said, if she didn't stop before he counted to three, he would spank her hand. He counted slowly and she didn't. So he did. She raged and kicked the furniture; her parents read their newspapers. They really were admirably stalwart. I had done a quick drawing of them, and Julia raging at them, and I passed it over to her. Still hiccuping with sobs, she saw what it was, and laughed. I *knew* she was a nice little girl and was very glad to be proved right.

The storm was over, lunch came. Julia had only eaten a little of hers when she went out like a light, and at the end of the meal her parents carried her sleeping form, still clutching the drawing, back to their sofa in the bar and later, still sleeping, to the car. They bought a bag of crisps to give her when she woke up, faithful in their promise. They were such nice people, off on a camping holiday. We were sorry to part from them.

As we drove through France the next day, I remarked on the shabby beaten-up auto scene. 'Were there no company cars in France?' I enquired of Tony, who thought not. That would explain it, as it explains the false air of prosperity among the British car population. All through France, which we took fairly slowly, pausing at cathedrals and markets and so on when we liked, the weather was fairish, warmish and windy, but as we left Beaune the rain began to fall. It rained and rained and rained. We left the beautiful Burgundy country and ascended the Juras, and it poured so hard we could hardly open the windows even a crack or without being soaked. We stopped at one point to have a rest from the huge, efficient windscreen wipers, set at 'frantic' all the way, and outside, through the sheets of rain, some cows loomed, tinkling their bells at us. Their bell collars were heavy leather with beautiful buckles.

We reached Pontarlier, headed on through the frontier, and the dramatic Swiss landscape glowered in flat two-dimensional grey screens through the rain until at last we came down, twisting and turning, to Yverdon, and then by the edge of the lake to Neuchâtel.

Along the lakeside, we delighted in everything being so neat and well ordered and Swiss, but when we reached Neuchâtel (where Tony had been at the university between school and Oxford) Swiss efficiency fell with a crash. We were soaked just getting from the car to the tourist office. It was closed. Why? Nobody could tell us. It *should* be open, we were assured, and we quite agreed. We climbed back into the car and sought the one at the station. It was closed too. What to do? 'Ask that tram driver,' I suggested, and the tram driver said there was a hotel just round the corner. There was but it was full. 'Can you ring up somewhere and book us a room?' Tony asked the girl at the reception desk as she turned back to the book she had been reading. Surprised, she smiled and did so, sending us out to the edge of the town to the best physical rehabilitation I have ever met.

We were so wet and cold, and when we entered the odd little hotel and stood on the pretty tiled floor water splashed off our clothes and made large puddles round our feet. This wasn't the night for a basic room with a reluctant shower – it was the night for a comfortable room with a lovely hot bath. And that is exactly what we had. *Toile de jouy* wallpaper, huge thick golden-yellow bath towels and plenty of hot water. Slowly we were restored to warmth and sanity and, presently, in the deserted hush of a sixteenth-century hall Tony was instructing a little Italian-Swiss barmaid how to make a vodka martini.

The relentless rain continued all night and we woke the next day to find it still falling. We were brought breakfast which was a poem – croissants as light as air, four kinds of Hero jam and excellent coffee. Let it rain. Who cares. . . . It did, however, preclude our idea of retracing Tony's undergraduate steps – his lodgings, his classroom, the refectory, the chapel and all that – because it wouldn't have been much fun on foot. So we rejoined our exquisite car and drove to the Collegiate Church where he used to have organ lessons, and we were very lucky to arrive just as a service was ending. In the pulpit, a minister with a sour expression was flinging a few prayers and then a blessing down on

his people as though he were hurling rocks at them, and then it was over and he stalked down the aisle, followed by an elder with the collection (which we had escaped), and was gone, ripping off his bands as he went. We lingered to explore the church. The organ had been restored, but opposite on the wall was a notice about how 'the bourgeoisie had beaten down idolatry in 1549'.

Outside in the square there was a statue of a reformer called Guillaume Farel, dressed like John Knox in gown and flat hat. He was in the act of throwing a huge Bible at the multitude, arms upraised and garment flying, and the legend on the plinth said the Word of God was mightier than the sword.

This set the scene for the stern Neuchâtel Sunday. Not a Sunday paper. Not a soul with other than a set closed face as they walked purposefully, and no doubt always usefully, under their umbrellas. The waters of the lake churned and heaved opaque grey. The rain now came down completely straight. There wasn't enough life in the place to vary it or slant it. Thankfully we got into the beautiful car. We must go somewhere. Anywhere was better than here.

We went to Fribourg, which Tony remembered as a pleasant town, and so it was. Fascinating and amazing. From a bridge in the middle, which spanned a river and a gorge, we looked down and saw, with astonishment, a completely perfect untouched medieval town. Tall houses leaning against each other as they climbed the gorge, a covered bridge, ramparts, towers, massive studded gateways, the lot.

When we found our way down into it, we found Fribourg as perfect close to as it had seemed from above – cobbled streets and squares and nothing to dispel the idea that it was fourteenth century or earlier. The few cars were so incongruous that one hardly noticed them, and the covered bridge, with its huge arched beams supporting the tiled roof, made them look trivial as they passed under it.

I tried later to recapture the colours as we had looked down on the town. The fawn-coloured houses flung across the matching river, the brown of the carved eaves and doorways, and the russet-brown

and reds of the roof-tiles – the only variation on this restricted palette being the gentle colours of the frescoes on cream or fawn house fronts, and the green of the trees behind them on the sides of the gorge. No blue. No yellow. No black or white or grey or purple. And the downpour had stopped to let us see it and enjoy it.

The following day we travelled on to Berne. Tony and our friend Jack had told me so much about what a wonderful city it was that I was surprised to dislike it. Tony said, 'It is all the wrong colour now that it is clean', and all the great heavy ornate buildings had been painted concrete colour. It had looked better brownish and dim, he said. It was all very splendid and Germanic, but we had no wish to linger, though I enjoyed the two men playing chess on a checked pavement with pieces the size of Alexa, our dachshund at that time.

(Alexa was staying with Joanna, and Joanna, in return, could and did park little Louise, and now her baby Antonia, with me whenever she liked. At one blissful moment in the car, Tony said, 'Let's not go home at all' and I said 'Alexa?', and he said, 'Oh, well . . .'. I said 'Antonia?' and he said 'We'll go home.')

On our way to Spiez we paused for lunch on a mountainside, down a little lane. We found a perfect place – not difficult in a lonely and beautiful spot with no houses, people or cars within sight. But, I need hardly say, the Swiss had thought of it first. There was a little bench under our chosen tree, and a little red litter bin, so it all looked like a stage set, as Tony sat on his neat little bench under his neat little tree, and the red bin and the red car beside us had been painted with the same paint, and behind him rose up the green hillside on which neat little cows tinkled their dear little bells.

Spiez was very Edwardian, most particularly our hotel, and it was on the lake, which I enjoyed greatly. We could watch the comings and goings of desultory lake steamers from the window of our 1900-period room in the turret.

'Trés romantique,' said the pleasant girl who showed us round, and what proved indeed to be romantic was a pair of mallard ducks who slept each night on the roof ledge outside our window,

careless of storm and rain. In the daytime they flew down to join their relatives – who all seemed to go about, touchingly, in pairs, the drake never noticing how much more beautiful he is than his mate. They swim together, fly together, sleep together. *Trés romantique.*

It was not difficult for the son of the hotel owner to identify the drivers of the Alfa Romeo. All our fellow guests were very, very old and were most unlikely to have arrived in such a car. He sought us out to say that, with our permission, he would like to park the Alfa in the courtyard, with the family cars, where it would be safer. 'Boys going home, you know,' he said darkly, 'and such a temptation.' I was relieved to hear that any Swiss were *capable* of behaving so wickedly, but we were grateful to him for his forethought. He brought the keys back to me when he had re-parked it, and handed them over, saying dreamily, 'Beautiful – what a beautiful car . . .' .

When we left he was waiting to see us off. 'I am sorry you are leaving,' he said. 'And *very* sorry the Alfa Romeo is leaving. I parked it outside my bedroom window so that I could enjoy it.'

We had to be on our way in any case, but we were both eager to have something to eat. The ancient residents, all of whom had been coming every June since time began, had very small appetites (they never *did* anything) and delicate digestions, so they ate tiny quantities of very nasty nursery food, all served with a considerable flourish. The chef had the temerity to tour the dining room after dinner but had the sense not to come near us.

The lights in the hotel were extinguished at 10 p.m. and when I looked out over the bay at the village half an hour later there wasn't a light to be seen. The mallards outside our window, lying so close that they might have been one bird rather than two, had been fast alsleep for hours. I drew them before getting into bed and decadently read for another hour or so.

We had meant to put the car on a train to go through the Simplon Pass, but found that one could now go through the Loetchburg

Pass and then on through the Simplon all on one train, so we could be in Italy in about two hours instead of the journey taking almost an entire day. The train left from Kandersteg, which was an enchanting village set in flowery fields, with serious climbers setting forth with alpenstocks, and notices pointing to the mountain hut. There were lots of younger women, as well as the more usual older ones, in full braid-trimmed skirts, with white puffed sleeves and coloured aprons or pinnies. The little girls looked ravishing in their mini versions of these outfits.

With great excitement, our Alfa was first on the highly efficient clean well-managed train. The next was an Alfa Berliner filled with Grandmamma, Grandpapa, Uncle Orlando and young Francesco, who were all having a violent Italian quarrel. Francesco was on one side, and all the others were yelling at him, and every time Grandmamma caught my eye she shrugged apologetically, 'Men . . .'. But during the journey the family must have settled the problem because, when we had to get on another transporter at Brig to go through the Simplon, they all surged round our car saying how beautiful it was, and how fast it went, glowing with national pride, all in accord. Whenever we looked behind us on a bend we could see the dear little fellow whisking faithfully along in our wake like a toy on a string.

Our next stop was Pallanza, on Lake Maggiore. After prolonged searching for a pension which had folded some time ago, we passed, for the fourth time, a majestic old-fashioned hotel on the lake shore. Not for us, we had thought as we drove by, but by dusk, tired of going back and forth, we thought we would just see . . .

What we saw was convenient for us but sad. A huge splendid place fallen on hard times, welcoming us as a change from the bus loads of package tourists, which was now its clientele, replacing the erstwhile crowned heads, film stars and celebrities of one kind and another for whom it had been built in the glory days.

We were given a big shabby room overlooking the lake, and Toscanini's Castle and, as darkness fell, the twinkling lights on the opposite shore. Paolo, the young man who greeted us and gave us

The Alfa on the Simplon train.

a handsome booklet on the hotel's first hundred years, became our friend. When we came down to dinner he sped from behind his desk in the hall to escort us to the dining room and hand us over to the head waiter, and ensure our five-star treatment. He brought candles and lovely flowers for our table, while everyone else had a potted begonia. We were much bewildered until we realized that everyone else there, in all that huge majestic room, was from one bus load or another. The prices the hotel was forced to charge brought it within the reach of all, even us, but we at least had

come voluntarily and not as a parcel, and we were rewarded for this.

Tony was the only man in the room with a tie on bar one. Later we talked to that man and his wife, a despondent pair who had never tried a package tour before and hated their exuberant, extrovert fellow travellers, from whom there was no escape. But we also talked to a very different couple when we took the boat to Etresa, calling at Isola Madre, Isola Pescatore and Isola Bella on the way. This splendid middle-aged pair were camping nearby. She had taken a job as a cashier at the Co-op to pay for it and was full of knowledge and information. They were going on to a Methodist *gausthaus*, having seen the advert in the *Methodist News*. They borrowed our *Guardian* in order to catch up with the cricket scores, and they were enjoying every minute of their holiday.

The Hotel Majestic continued to treat us splendidly throughout the few days we were there. Every night I found my nightdress arranged elegantly on the bed, the waist all pulled together, the skirt spread wide, and flowers and fruit appeared in our room, fresh every day. The food was fairly dreary (it had to be to fit into the modest price we were paying), but we had the best of it and often something special. Seeing envious eyes from the next table cast at our delicious fish one night, I said, 'We didn't order this, did we?' Paolo's friend the waiter shrugged and said, 'We only had two. It would be a pity to waste them.'

We never managed to leave the hotel by car without Paolo materializing on the steps, 'Just in case you want a push,' he cried, never tired of his joke. As we sped through the hall one day he was on the telephone and we thought that for once we would escape. But no. 'A moment!' he said into the telephone, and rushed after us. 'I have to hear that lovely engine start! Don't deprive me of such a treat.' When we left finally he was there, and all the boys from the dining room and the little maid who had looked after our room and so admired the paintings all laid out on every surface to dry. 'One more look. One more look!' she pleaded, tugging at my portfolio. The top painting was the view from our window, across the water

to Isola Bella, so I pulled it out and gave it to her, and she flung her arms round my neck in a warm onion-scented embrace.

We had had hot sun, and had swum in the warm waters of the lake from the hotel's own little beach (totally deserted save us whenever we went there) and had seen the famous Tarante gardens, where Captain Neil Mac Earchen, who made them and left them to the nation, lies in the little octagonal chapel built for his marble coffin after his death in 1964. There was a service there on Sundays and we made for it. The domed roof was rather crudely painted with sky and clouds, but the eight round stained-glass windows were lovely. St Christopher and the Christ child behind the altar, and all the others beautifully done, delicately drawn flowers and trees. The congregation of four old men and women sat on the only chairs and the rest of us stood behind them during the simple and straightforward service.

Out in the blazing sun again (the locals kept complaining about the heat, so perhaps it was hotter than usual), we saw the first formal exquisite pink lotus flower to come out, standing surprisingly straight on the stalk, rising about 2 feet from the water. Beautiful giant magnolias, all over Pallanza, were just starting to bloom, the grandest of Grandiflora. And all the oleanders were out, white and pink and cherry red.

There was a fiesta one night, and the whole town was *en fête*, frying sardines in the square, flags and bunting and dancing everywhere, all waiting for the firework display. We waited too, and at about 10.30 one small unenthusiastic firework went up silently, scattering a few desultory stars. 'Aaaaah!' sighed the

crowd in delight. In the next half hour a few more followed, but not many and they were rather small, and that was it. However, everyone was exceedingly happy, and the music went on most of the night.

We passed through early the following morning. Everything was cleared up, cleaned up and put away. The tables and chairs and banners and flags and barbecues and stalls were all gone, and there wasn't one scrap of litter. Only the faint smell of cooked sardines hung in the air and clung to the magnolia leaves to testify to the fiesta.

There was an international veteran car rally in the square too, and people came from near and far to see the ancient cars, and often equally ancient drivers. (Among the fans I spotted another Alfa Romeo GTV, and that was the only one we saw in our entire Italian sojourn, so no wonder we attracted attention if, as Paolo said, 'This car is every man's dream.')

Among the veteran cars I enjoyed a huge shining ancient Rolls, driven by its bewhiskered contemporary, an Englishman, who was accompanied by his wife. She had no truck with the camaraderie among the drivers, the touring of the other cars, the drinking together and eating together, never mind the lovely leggy girls who seemed to be brought along in so many vehicles. Instead, this English lady sat high up on her throne-like seat, imperviously doing her canvas work. Spectacles on nose, sun hat on grey head, she sat in the full sun stitching away as though in her own drawing room, completely ignoring everything around her. Presumably this was how she endured the whole rally, right across half a dozen countries. No doubt she had a splendid set of *gros point* dining room chair seats as a result.

We stopped briefly at Ventimiglia on the way home, before we sadly left Italy for France, to do some duty free shopping. It is our permanent fate there; almost all the shops were shut. There were a very few open, and Tony bought me a small red overnight case. 'Red?' I asked. 'To match the car,' he said firmly.

When we left Cogolin and turned on to the autoroute for home we decided to see what it felt like to do the ton, illegal at home but

still permissible in France. Tony was taking his two-hour turn at the wheel, and settled easily at 110 m.p.h. When it was my turn I felt quite comfortable at 105, and over a fifty-minute time-check kept up an average of 97 m.p.h. in heavy traffic, so we got on quite quickly, our nerves taut, and mine at least extremely tired at the end of it. But it was interesting. It was only later that we found out that exceeding 100 m.p.h. had become illegal in France, too, that very day . . .

In the American Constitution there is a phrase about 'the pursuit of happiness' which always strikes me as particularly idiotic. Happiness is not responsive to pursuit. Happiness tends to come by chance, and when least expected, and from the most unlikely sources, as it did this time. We had never aspired to smart special cars or given them a thought, and, having acquired one by accident, had no idea what fun and what a pleasure it could be.

I am not a car snob (which is just as well considering the general run of our cars), so I wonder how it is that I *still* have the Alfa Romeo fob on my key-ring?

Skopelos

We tried island-hopping in the Sporades, and came from Alonnisos to Skopelos on the ferry which circulated among the islands, arriving there at about 8 in the morning when everyone in the little white town climbing steeply up the hill still seemed to be asleep.

We had booked rooms through an agency and when we found the office in the harbour the young man inside was at least awake, but totally distracted. He was overcome, he said, by the responsibility of getting thirty people away on the ferry to Skiathos; if anyone were to miss the boat they would miss their charter flight. Such a heavy responsibility, he declared dramatically, and we saw that we would not be able to get any sense out of him, or even engage his attention for a second, until the ferry had departed with his thirty passengers, in thirty minutes' time.

The three of us were rescued by a theatrical figure in dark glasses and a jaunty cap. He introduced himself as Ingo and was clearly the island's 'Mr Fixit'. He took charge of everything and spoke excellent English. 'Leave that! Do not touch the luggage! I will arrange it. Here is the car. Here, please seat yourselves. I will take the suitcase. And the personal luggage,' he declared, staggering under the unexpected weight of my book-filled flight-bag. He leaped into the driving seat, and turning back to me handed me a tiny pink flower plucked from a bunch in the glove pocket. 'Madame, here is a flower which says welcome to Skopelos. Here we have no tourists, only friends. You will find all friends,' and he drove off with brio, chatting and calling out all the way. 'Silly old ya-ya, move yourself. You want to be mince?' and 'Good morning, Papa, I shall be good today!' and 'That is right, girls. Admire my excellent driving!', in between flinging us bits of

useful information. After what seemed like many miles we arrived at a house at the top of the town looking down over the roof tops to the sea, where we were shown into a decent enough little room containing twin beds, a tiny cupboard between them, a row of hooks, and a curious sort of coffin made of wire and plastic in which we were presumably supposed to keep our clothes. As we could never master either opening or shutting it, we put our suitcase on top of it and used that instead. We also had a balcony with a table and two chairs, and in the evening delighted in watching the yacht flotillas coming in to berth, voices carrying up to us in the clear air as though they were only yards away, instead of the seven minutes' walk – well, seven minutes going down but somewhat longer coming back as it was so steep that most of it was steps.

After a day or two we made sure we were on our balcony at the right time, because each evening's flotilla arrival seemed more hilarious than the one before. There were very few people who knew what they were doing, and as they approached the harbour one could watch them all hopping about on the deck, very anxious and busy in their bathers and tiny cotton hats, all shouting at each other with increasing irascibility and finally making three shots at getting the boat moored before coming ashore still quarrelling about it.

One evening we saw a boat coming in some time after the rest of the flotilla and, even from on high, one could tell from their long-sleeved shirts, long trousers and huge floppy hats that this time the occupants were far from young. They made a really disastrous mess of trying to moor, and the shouting and swearing (and shrieking on the part of the wives) was prolonged. It was embarrassing to watch, and I really felt for them, but I couldn't look away. Not at that point when it seemed they would haver back and forth till morning, and never get near enough to the quay to tie up.

Fortunately for us all, there were always a few locals hanging about the harbour, only there, it seemed, to tie up any vessel from

a dinghy to a big car ferry, and one of these rowed out and laconically boarded the elusive yacht, calmed the occupants and brought her neatly in. We then watched them all come ashore – one of the men handing over a handful of drax to their rescuer – and toddle off in their ludicrous hats to find themselves dinner, still arguing and thoroughly cross.

It was our good fortune, much later, to find ourselves in the same taverna so I could look under the hat brims and see what they were like. They were all feeling better after a prolonged dinner and plenty of good local wine. Three red-faced men in their fifties, and three matching wives, two plump ones and one very thin, huddled in a sweater, her grey hair skewered on top of her narrow head.

'The good parish worker,' Tony murmured. 'Her husband's a church warden. Where would we be without them.' I have never dismissed his guesses since he once looked across the dining room of a small hotel where we had just arrived in a remote part of Spain, and, resting his eyes on a perfectly ordinary decent-looking man dressed, like every other man, in cotton shirt and trousers, said, 'English of course. An estate agent, probably Bromley. The only child of elderly parents, a gardener and a golfer.' Later we got to know his victim, and Tony had been *exactly* right on all counts, even Bromley.

I was glad that the church warden and his friends were all at peace again and were clearly enjoying their evening, but wished I hadn't heard one of the women muttering to another as they went out, 'I absolutely *dread* tomorrow in Skiathos. All those great big boats and so many people around to watch', and the other say, 'Oh don't think about it. Perhaps we can persuade Donald to have a go at it.' Having by then identified Donald, I had my doubts.

A lane ran past the house we were staying in and turned a corner, and now and then a donkey would patter past, and very occasionally a car or farm vehicle. The lane branched at the corner, and ran in minor form up the hill into the trees, but a stalwart pole and cable indicated that something happened there. It must, we

concluded, be the house of a small, old couple who went by every day before sunset, laden with bundles and bags; so one day we followed the lane at the glowing end of the day to see where they lived.

The little house was not far away, just round a corner, and there the cable ended. Oddly there was no sign of the old couple, who had preceded us by an hour, but it was nice to think of them going to such a comfortable place at the end of the day. We walked on as the lane became a rough goat path, and climbed up the rocky surface between the trees, hoping to reach the top and see where we were.

Then, abruptly, the path stopped. It had reached its destination, a tiny windowless stone hut, with a light flickering inside the open door. The old lady was taking in some washing pegged on a line between trees, and her husband, absorbed in drawing water from a little well, hadn't heard our footsteps. She saw us, however, as she turned to go in, and greeted us politely. We wished her 'good evening' and made to return down the steep path but she called us back. Greeks are so hospitable – I did hope that it wouldn't be a tiny saucer of jam, which I find hard to eat all on its own. It was, however, water from the well in two grubby plastic tumblers. We were very grateful and honour was satisfied. We had a lot to think about on the way home, reflecting on this seemingly contented pair, and their narrow unchanged lives, and the choices they had made, and their placid smiling faces.

Skopelos is green and wooded, and we walked and climbed for many miles, sometimes up green hills where we couldn't see beyond the trees, which I felt a great waste with all the wonderful sea colours around us. The houses and farms were sparse, which was a surprise in view of the fact that there must be thousands of cocks on the island. The nearest ones began to crow at dawn, all close around us, and they wakened all the dogs (as well as me, but at least I didn't bark – all the dogs did). Then an outer ring of cocks and dogs would stir, and when they were all going strong, yet another, further away, until layer upon layer, right across the

island to the sea, there was this madrigal of crowing and barking until full daylight.

Our walks were sometimes much longer than we had intended because we only had Greek maps, which owe more to imagination and hope than fact. So a road or path would be confidently marked on the map when in fact it had only been started, and stopped abruptly in a rocky waste after half a mile. But there were many diversions along the way, such as ever-fascinating ants, busy on some project, with every one knowing exactly what to do, and Red Cross ants being sent to the fallen, and reinforcement ants to help with a heavy load, and so on. Or a pair of black and white butterflies, the male much more boldly marked than the female, having a stately flirtation. He did a formal dance, and she watched in admiration and fluttered gently. Then she coyly flew a few inches on to another twig, and he followed and did the dance again, exactly the same, wing-shake, half-turn, wing-shake, and again she admired and fluttered and moved on a little. When we left them after ten minutes they were still at it. I have often wondered since how long it took them to achieve their objective.

We found a beautiful bay called Panorma, a huge sweeping bay, and, around a little cypress-marked point on the left, another smaller bay, a perfect natural harbour, with clear deep cerulean blue water. Strung along the back of Panorma were some houses and a couple of tavernas, and behind them a valley and a sugar-loaf hill covered with silvery olives all glowing in the red earth. This was once the ancient city, long abandoned, and the hill is covered with

the ruins of stone and marble. The stone, which is quarried about a mile inland, is beautiful – coral and cream and pale blue.

Great battles were fought there long ago when it was a well-inhabited and important place, huge triremes rounding the headland and able to come in six at a time, or more. The water is very deep: three steps and one is out of one's depth.

A dragon used to live in the valley behind the bay, and he disposed of all criminals in the Sporades, who were brought to Skopelos and put ashore for him to consume. But, though he thus saved the taxpayer considerable sums, the dragon also ate mules and goats and local inhabitants. It was particularly awkward about the goats, because the island was and is very dependent on them for meat, milk and cheese, the last being made and stored in goat bladders. As the goats provide all these useful services, and only ask in return to eat the dry branches of the low bright-green shrub growing everywhere, they are very valuable, and people resented losing a goat to the dragon even more than the fact that he could and did knock down a cottage with one swish of his tail.

In the third century AD, the good Bishop Righinas decided to deal with the dragon, so he travelled with the next boatload of prisoners, landed at Panorma, and, carrying a crucifix, was the first to step ashore. Some say he just shouted 'God!' and raised the crucifix at the dragon, who came charging down for his lunch, and some say he began preaching (he was famous for his rhetoric), but whichever it was the dragon turned tail and ran away, and the bishop ran after him, preaching all the way.

Bishop Righinas preached all across the island, right over the high mountain ridge we had walked so recently, until he had driven the dragon to the edge of the cliff with the sea far below. There the dragon had a dreadful choice, either crashing into the rocky sea or more preaching, but at that moment the earth split into a huge ravine (we knew, we had walked all round it) into which the dragon disappeared and was never seen or heard of again.

The good bishop was therefore rather attached to Skopelos and preached there for several more years until one of the endless

invading forces beheaded him on the old bridge outside the town. This explained why everyone in the bus crossed themselves as they passed over the bridge, which had puzzled us. Once we had heard the story we went to look at the hideous bronze and marble memorial erected there in the bishop's memory, where a perpetual light shines, and on which is an inscription in ancient Greek (which the islanders can't read; but, fortunately for me, Tony could) recording his dates and martyrdom.

We soon picked out our favourite taverna near the harbour, partly for the particularly amiable waiter, partly for its position – it was lovely to dine among all the lights reflected in the sea – but mostly for a group of small boys who herded about there. They were probably the younger brothers of a few six- and seven-year-olds who were competent water boys, and, surging around in the taverna, the younger ones were learning the trade by osmosis. One of them was a golden boy, probably four years old, golden skin from the sun and golden hair, so that the blue of his eyes came as a pleasurable shock when he looked up. Though he was not the oldest or the largest of the half-dozen little mates, it was quite clear that he was the leader. The others all wore clothes, but he was always in bathing pants, even on chilly evenings. He usually had a piece of bread and a bottle of water with him, and gave bits and sips most amiably to anyone who asked. Clearly they could all have their own bread and water, but equally clearly it was more prestigious to have some of his.

They all played around the jetty and the boats, pulling them in, climbing aboard, 'fishing' by hurling out a line with a hunk of bread on it, but the Golden Boy was the initiator in whatever they did, without ever seeming to be boss. Was it because they were ordinary and he was beautiful? It always seems so unfair of God to give a few people such an advantage, but since He couldn't make everyone equal (and how dull it would be if they were) it is just as well if the privileged learn to handle their privilege early on. Certainly this child did. He was generous, patient and forbearing, and full of ideas. The moment his mini-mates became bored with

something, he had them doing the next thing, and he was always quick to notice if they were in difficulty or if a quarrel was brewing up. I did so hope that he had a good future ahead of him. Surely he couldn't look like that, and behave like that, and fail?

Once I had the pleasure of painting a beautiful old man. I hadn't known him in his youth so didn't know if he had always been beautiful, or whether he had become so because he was, as I well knew, so honourable and true and good. If the former, had it not helped him all his life that his appearance gave people pleasure? Would it not make one feel the world was a kinder place if everyone smiled on you?

As they do on first meeting good-looking people. Even babies and two year olds, too young to be conditioned or conventional, prefer the attractive-looking little girl or boy. It is a pity that so many with the gift of beauty waste or abuse it. They don't, alas, all grow up to be like my model Nigel Hoare.

The Golden Boy had, of course, more than good looks, as was demonstrated day after day to us as we watched the little group amusing themselves in his care.

I remembered our son Andrew, returning, aged eight, after his first term at a new school announcing that he had learned something. I said, 'Oh, good. What?', thinking of a breakthrough in some sticky subject such as maths. 'I have learned', he said, 'how people are divided. They are divided into natural-born underlings and natural-born toplings, and however you are born that is how you are and you have to accept it and get on with it.' Even taking maternal prejudice into account, Andrew didn't look to me much like an underling, but I asked if underlings might not become toplings in time if they set their minds to it? 'I doubt it,' he said. 'I don't see how they can, but I'll see. I'll tell you when I'm old.'

I must remember to ask him, not that he could yet be counted as old, but, as a Silk, he would presumably be counted in the topling category, however he reached it.

I do hope the dear little Golden Boy, so clearly 'a natural-born topling', has fulfilled his destiny too.

The Clear, Clean Colours of Mykonos

One of the many charms of the Greek islands is that each one – to judge by the two dozen or so that we have stayed on – is so different and so entirely itself. Mykonos must surely take the prize for the clarity of light, every infinitesimal particle of dust being presumably blown away by the wind.

However it comes about, the blinding white houses and churches set against a deep-blue sky, the clean lines of the barren headlands (which are in fact covered in wild flowers and herbs and smell delicious as well as sounding wonderful, thanks to the larks), and all round seas of peacock blue and emerald green and turquoise, are all quite out of scale with most of the world's colours.

We had only our flight-bags to carry as we landed from the inter-island ferry as the airline had lost our luggage, so we had no need of the services of helpful strong-armed boys as we made for the rooms we had booked. If my senses were still stunned by the light and the white, and the long blue late-day shadows, there was no respite in the ground under our feet. All the doorways and all the little alleys as we walked up towards our destination were decorated with elaborate glitteringly white lacy patterns painted between the cobbles.

I was reminded of the elaborate chalked patterns that women in the Glasgow slums, when I was a child, took such pride in making in the doorways of their close. The Mykonos patterns had, however, a different source. Before the days of cement and concrete, when the cobbles were laid in bare earth, the women painted the earth with lime to deter the ants, and the painting remains (and, knowing ants, probably they do too).

In the morning, having no bathing kit and the shops being few and limited, we pondered what to do until our luggage turned up – and we ardently hoped it would. We had the clothes we were wearing, our sponge bags, books, spare underclothes, and I had a sketch-book but no paints. A scout round the town – limited by the fact that we needed a shop that would accept credit cards as we had no money until the banks opened the next day – produced a bikini for me and a towel we could share. Tony always wears scarlet pants, and he said a pair of those would be his swimwear so, roughly speaking, we seemed to be in business and we set off over the headland to find a likely beach.

Even in the strong wind we could smell the varied herbs crushed by our sandalled feet. Familiar scents of thyme and rosemary and sage mixed with unfamiliar spicy ones, and one which smelled of curry. (Later I met a Greek botanist who identified it at once as *Trigonella foenum-graecum.*) The wind was so fierce that we were quite relieved to dip down, eventually, to the sea, and find shelter by some rocks where we could dry off in the sun without using up our miserable little towel, and with miles to walk and plenty to read we spent several contented days in this fashion, but I mourned my paints.

Everywhere I looked, everywhere we went, I wanted to paint, so it was a very great relief when our two modest but essential bags turned up. Even the skeleton of a house behind the one in which we were staying beckoned me. Half-built, and abandoned long since judging by the weeds growing in it, the sky visible through its empty windows, it taunted me, but I did manage to record it before we left.

Some of the beaches, we presently discovered, were a long walk away, and sometimes we felt daunted by the relentless wind and went by bus instead, but it was inadvisable to try the bus after about 10 o'clock because by then all the other tourists had woken up. It was not high season, so the place was not flooded with tourists, and, as my Greek botanist friend said, 'Mykonos is still the place for artists and writers, and not for those who want

expensive pleasures' (which may not obtain today but certainly did for us). All the same, the buses were crammed by mid-morning. Not only with visitors, but the locals going home, having done their shopping in the town, and they were carrying as much baggage, though of a different sort, as those who were headed for the beach, with their snorkels and goggles and flippers and all sorts of apparatus of that kind, and lilos and wind-breaks (much good those were – being made for Seaford or Walberswick, the Mykonos wind thought them simply frivolous), and, of course, babies and push-chairs and all *their* requirements.

The buses were old, with no luxuries like racks or alcoves, and one morning we were delayed and only just managed to squeeze on to the overcrowded bus, and edge our way up the aisle already full of people standing, to perch on the engine casing beside the driver for the half-hour journey to our chosen beach. We could do this because we had nothing with us except our two straw mats, our books and bathing towels, and it felt like sitting on a shooting-stick for the journey, from which we could survey our fellow passengers. Our nearest neighbours, a black-clad white-headscarfed lady, had a pair of indignant hens, tied by the legs, on her lap, and beside her, her husband peered over a (slightly leaking) sack of flour and a roll of wire netting. Behind them sat a large young man, very blond and Scandinavian, who was closely involved with a companion who was already a puzzle to the children across the aisle. No wonder, really. A very deep voice emerged above a blue chin, and muscular hairy arms protruded from a pink lace blouse embroidered with sparkly beads, the whole effect crowned with a fragile, rose-trimmed sun hat.

The children, quiet English children with their quiet English parents, and their M&S sweaters and dutiful cotton hats, kept looking at each other, round-eyed, every time the pink lace wearer spoke, or more disconcertingly, laughed, but a quelling look from their mother prevented them from asking questions while on the bus.

When we were already overfull and past our departure time, and more and more people were pushing into the aisle and the bus

driver was still enjoying his ouzo at a nearby café table, there was a disturbance as someone else was obviously determined to get on board even if there was no room at all. As the people in the aisle crammed together, spilled over those seated and looked understandably irritated, the cause of it all eventually charged and barged her way through. A thin bespectacled American woman, with a huge beach bag slung over her shoulder, and in her arms a small, almost bald, child wearing big boots on his big feet.

Using the child as a battering ram she pushed her way forward, using his feet and her bag to deliver biffs and bangs wherever she could, with no apologies. Tony and I sat glued to our 'seats', won ten or fifteen minutes earlier, and we were not going to give them up, hot and hard as they were; our beach was a good half-hour away.

'Excuse *me*,' said the American, thrusting the child between us. 'He wants to drive the bus.' Barging through, she put the child in the driver's seat, and then in loud flat tones which silenced even the Greeks among the passengers she began, 'That's right, Jason, now turn on the ignition. Are you backing out now? Left hand down, left hand down, sure, you're the driver man. All the people know Jason is the driver man. Change down now, Jason, that's right. What beach are you going to today, Jason? Jason tell mother.'

Jason, after further prodding, muttered, 'Psarrou.'

'No Jason, *Elia* beach. Jason say *Elia* Beach,' she nagged. Jason muttered again. 'Sure you're the driver man. All these people know you're the driver man. Now here comes the big driver man.' Jason grizzled at being extracted from the driver's seat. We passed him across us back to his detestable mother, and clung to our seats. She was forced back into the aisle and made a loud fuss. 'You just hang round mother's neck, Jason, mother has to get her money out for the conductor man.' (None of them, incidentally, were 'conductor men'. They were conductor boys aged ten or twelve, presumably because no adult could squeeze between the people.) 'Mother finds it very difficult to get her purse out and hold Jason too,' she

grumbled loudly, on and on, until a girl with a softer heart than ours offered to have Jason on her knee. Jason objected stridently so the girl had to give her seat to mother, which was just what mother intended. The bus presently paused and the driver jumped down to deliver a parcel. At once mother began pushing and shoving her way forward again – 'Excuse *me*. Pardon *me*. He wants to drive the bus' – and had just got Jason, who had kicked us both smartly en route, into the seat when the driver came back.

Back in her seat, complacent as ever, she held Jason up to the window across a not at all pleased elderly man who was sitting beside it. 'See the chapel, Jason? What colour is its roof? Jason tell mother. Blue, isn't it? No, that's not a horse. That's a donkey. Jason tell mother the difference between a horse and a donkey.'

As she held him nearer and nearer the open window, and the poor man who was having his knees churned up by Jason's giant boots shrank further and further back into his seat, I felt sure that everyone on the bus was silently thinking, as we did, that if only the next jolt in the road shot Jason through the window it would at least shut his mother up. Poor Jason. He couldn't help his looks or his mother, but he was assuredly bound for a rotten life in the hands of that terrible woman. When, presently, mother and Jason got off, there was a profound and grateful silence. All the polite Greek villagers, the women in their cotton scarves, the men in battered blue caps, all the varied tourists, even the hens, all were giving thanks that mother's voice had stopped.

Then one of the little English children spoke softly. 'Mum?'

'Yes, dear?'

'If they got off there, they have 3 miles to walk to Elia beach.'

'That's good,' said her father grimly. One couldn't help feeling seriously sorry for Jason.

One morning we woke early (in my case very early: I'd been painting on the balcony for a couple of hours before Tony woke up) and decided to go to the sacred island of Delos since the wind was slightly calmer. Not much, but enough to encourage us.

We breakfasted in a garden overlooking school gates and it was very diverting watching all the good little children, none older than ten, arriving in their blue overalls, their satchels slung between their shoulder blades, their hair neatly brushed, dutifully turning into the school. It must have been an exam day, as a teacher stood at the gates inspecting the little boys' books. The girls, it seemed, were free of suspicion.

A mother with a very loud grievance aired it to the teacher for a good ten minutes. The teacher went on checking satchels. The mother flung her arms about and shouted and rolled her eyes. She clutched her white cotton headscarf in her hands and wailed and rocked backwards and forwards. The teacher just went on checking. Perhaps the mother was simply saying, in a Greek manner, that her child didn't like his lunch.

Two very small girls, aged about six, met in front of the school gates with such dramatic astonishment at seeing each other that one dropped her satchel with a shriek and spread her arms wide, while the other jumped back with an exaggerated start, before they rushed to embrace each other. I expect they greeted each other like this every morning of their lives. A man came by with his donkey, the two little panniers filled with vegetables and marguerites, which the school mothers gathered round to buy – and suddenly we had to run or we would have missed the expedition to Delos.

We got on to the wide shallow little vessel and tossed and lurched our way over an opaque ink-blue sea, whose white crests dashed all over us, for about forty minutes, before eventually

arriving at Delos, where we walked about a mile across the island towards the main excavations.

Delos is covered – entirely covered – in purple helichrysum and tiny scarlet poppies, and a dandelion-like flower which grows on great prickly branches. Tony was enchanted to see acanthus just coming into round purple flower, having read of it so often in the classics.

The seemed to be plentiful wildlife. Huge and brilliant butterflies, lizards of all sizes and in all directions, some very large and green, and in the splendid old water tanks bright green frogs making the most astonishing sound straight from Aristophanes – 'Rekekekek koax. Koax'. As we walked along, a hare suddenly leaped up from the flowers and the wild oats right in front of us, looked appalled to see us, leaped to the right, leaped to the left, and with one vast curving bound, was round us and off down the path behind us in a crazy terrified zig-zag.

Near the museum two thin pretty kittens, tiny faced and giant-eared in the Greek manner, played Cowboys and Indians with a dead lizard, while their mother lazed in the sun watching them.

Once the city of Delos was home to 20,000 people. Now, one can still climb through the ruins to the sacred 3,000-year-old road of steps to the ever-receding top of Mount Cynthus, and walk among the houses and streets which the French have assiduously uncovered over the years. All the buildings were made of such marvellous materials, the grand ones of marble, with exquisite mosaic floors, and columns and doorways made of a white granite so full of mica that they sparkled in the sun. There was mica everywhere. We climbed over a yet to be restored house, just a pile of rocks, and the rocks were cream and white and honey coloured and pink and dove grey, all glittering as though woven with lurex. All chosen carefully, no doubt, by some long-ago Roman magistrate or banker when building his magnificent villa. For Delos was the Wall Street of the Ancient World, an odd fate for a tiny island with no decent natural harbour and already sacred because of being the birthplace of Apollo.

In 750 BC the island of Naxos sent a gift of nine huge lean graceful white granite lions. Only five remain, but vast and dignified against the blue, blue sky, an honour to see. As we stood gazing in delight at them, a young French couple appeared, and the man posed his pretty girlfriend leaning on a lion, reaching up as though to kiss it. When they left I said unhappily to Tony that it seemed to me insulting to the lion's dignity. I had no idea that the young man had paused in an alcove to fiddle with his camera, so overheard what I said. He emerged and came back, saying, 'You are right. Poor lion. We were wrong to do that and I apologize to him. I shall tear up the photographs when they are developed.'

As we left the excavations, two pelicans flew overhead. They lived on a roof in the harbour, and they flew above us, back and forth, as we returned across the island to our tossing and lurching little boat. The boatman had been right when he warned that a

51

storm was brewing, and we had a turbulent trip home under a sky the colour of black grapes. We just made it to shelter before the rain came down in sheets of water, bouncing a foot high off the concrete around Mykonos harbour.

For our last dinner on the island we decided to return to the charming family run restaurant a Greek friend had introduced us to, and where we had spent several very contented evenings. Dad did the cooking, and Mum served, and the two elder sons were willing but not very efficient waiters, and their seven-year-old brother was a busy little water boy. The food was a bit better than most, so the restaurant was always full, but no matter how full, they always set up new tables on the cobbles outside, and the boys cantered about faster than ever, delivering the food to the wrong tables.

On only our second visit we were welcomed as though we were long-lost friends, and by now, several dinners later, we were such honoured friends that a table-full of – admittedly very good-natured – uncles and aunts and cousins were shifted to a lesser table so that we could eat at one we had liked before. We protested in vain. Our hostess stroked my arm and patted my hair, as she was wont to do *en passant* when bustling between the tables – it was a mannerism I had become used to since our first visit to Greece years before. Village hospitality means kitchen chairs brought out, glasses of delicious cold water, and some elderly lady sitting down beside me to stroke and pat me though we couldn't converse in words. As Tony can read Greek, though he can't speak demotic Greek, and I can draw, we had means of communication of a sort, and got on very well, but I did realize that there was a point to the stroking and patting and wished we could sometimes put it into effect at home.

On the occasion of our last dinner we really did want to thank the family for our delightful evenings, so were very pleased when Alcemine, our friend from Athens, turned up to translate for us. We went around the tables shaking hands with everyone in sight, and then into the kitchen to thank Mr Maky (so stately, for all his

5 foot 3 inches, in his chef's hat). He said it was an honour to cook for people like us, and from Mrs Maky I had kisses and embraces, and suddenly tears were pouring down her plump cheeks as she said to Alcemine, 'Take her away before I weep with sorrow to see her go,' and she turned, weeping very loudly indeed, into her husband's reassuring arms.

I wondered what on earth it *felt* like to be a Greek?

We were glad, both of us, to discover what Mykonos felt like and looked like. The purity of line, the clarity of colour, the stern sweeping headlands where the grasses and herbs grow on a thin layer of earth, and everything has to survive the unforgiving wind. Wherever we walked tiny blue-domed chapels were tucked into folds and corners, over little bays, on top of cliffs, each one with a stone seat outside for communal feasting at festivals. Towards the end of our stay we were amazed, one day, to witness the arrival of a cruise ship, and a slow snake of people come ashore to slide very slowly along the road to some point of interest, and then slowly back again to seep into restaurants and bars until they were once more summoned on board. Leaving the little town all day, every day, and exploring the rest of the island on our feet, we had no idea this happened, and, in season, every day.

It was clear, however, that the Mykonos these poor people saw was not the one we saw and had so much enjoyed.

Reflecting on Colours

Learning to paint is simply learning to see, and of course if one starts looking at the world with a painter's eye early in life, it doesn't necessarily make one a good painter, but at least one has *seen* it on the way along, and registered the colours and the shapes and the comparisons because that becomes a habit.

Newcomers to painting sometimes find colours difficult to see, and then to translate into paint, but these problems ease rapidly with practice. It is usually easier for women than for men. Men can, and often do, canter through their lives largely unaware of colour, their most acute colour problem being 'is this shirt all right with this sweater?'. And even that ponderous question would not occur to a large number of the male population.

With enthusiasm, which is an essential ingredient in an aspiring painter, anyone can learn to discern colour and to imitate it on paper or canvas, though it takes years of using paint to be able to look at a painted tree and know which colours were used in it, and therefore to be able to mix exactly the colours to match it without too much time and experiment.

On the way along, every painter acquires prejudices. I knew a man who refused to use earth colours. I never could imagine how he survived without burnt sienna, never mind raw umber, which is such an essential modifier in all sorts of mixtures that it always reminds me of people who have a talent for mediation or 'fixing' in difficult situations so that they are called in to solve financial or international crises, and this is their life's work, these raw umber people.

I admit to as many loves and hates among my paints as the next person. I have phases of hates; at the moment for yellow ochre, which appears to me a heavy boring colour and whenever I need it

I find I can just as well use the lively transparent raw sienna instead. And phases of love, of course, when I find a new colour and feel it will not only change my painting but my whole life and I can't wait to explore all it can do.

I am teased, I need hardly say, about my unnatural fixations, such as my loathing for Paynes' Grey. It is a colour that seems to me the essence for idleness and amateurism (using amateur in its usual derogatory sense rather than its true and beautiful sense of meaning one who loves). I have seen so many amateur paintings entirely wrecked by it, by a painter who reached for the Paynes' Grey whenever he or she wants a shadow, so there it is on a brick wall, on a white fence, on the grass, on the flank of a bay horse, on a wretched child's face, on the sea, up in the sky mixed with a large amount of white . . . On and on and on. And the wretched stuff is simply made of French ultramine and black, with a touch of yellow ochre, so anyone who really seriously wants it could mix it for themselves with very little trouble. Enough trouble, however, to make them pause and consider long enough to wonder whether it will make the right shadow for all the aforesaid items.

People who are not wont to haunt art suppliers would hardly believe that there is a colour on sale and, presumably bought, called 'Flesh'. There should, therefore, be another called 'Hair', if one follows this line of thought. And perhaps one called 'Eyes'. Why not?

I am all for saving time and having all sorts of luscious mixtures of colour ready in the tube, but not if it is simply ludicrous, and would also hinder rather than help those who are struggling to see for themselves.

There are enormous swathes of painterly knowledge which pass me by, and in one of them is contained the chemical composition and reaction of every single colour on its own or mixed. A painting friend, who has now, alas, died, knew it all, and I learned as much as I could from him every time we met. 'No, you can't get the colour you want if you use cadmium red because cadmium has too much opacity for the blue you have chosen.' It

Maria Spain, Mina Baruch and Tony in the exhibition at the Air Gallery, Dover Street, London, March 1999.

was all in his head, while I have acquired a little of this sort of knowledge painfully and with long experience. Seductive as the displays of paints are in art shops, it is not surprising that beginners quail before them. Confronted with names as hard on the tongue as on the memory, a dozen reds, a dozen blues and yellows, it is simply frightening. There is nothing beguiling about the sound of Quinacridone Orange, or Capuut Tortium Violet or Phthalocyanine Green, though the last, for all its creepy name, makes the popular Hooker's Green when mixed with two yellows like ochre and cadmium lemon. Hooker's is so much easier to say and remember: no wonder people buy it.

Yesterday, looking appreciatively at my palette, all set out to begin work, I thought the paints were like the components of a good dinner party. The reliable friend, always ready to help and a comfort to have around, the wacky one with no great depths but

a great ability to liven things up, the timid retiring one who needs to be looked after, the passive one who is essential to listen to the man who loves best the sound of his own voice, and the strong uncompromising personality who must be prevented from dominating the whole table. With luck, the painting on the canvas, and the dinner party round the table, comes together in pleasure and harmony, and if either fails it is for the same reason. One of the elements has become out of balance. The problems of where and how to put it right are absorbing and pervasive with regard to the painting. (The runaway dinner party is much harder and fortunately, by next morning, often extremely funny.)

Professional painters – that is to say, those who make a living by painting non-stop – quite frequently fall into bad and narrow ways, and can only see the colours they normally use and no others. My own problem – or one of my own problems – is being too easily intoxicated by colours. My judgement is suspended, my balance awry, my brain whizzing as I fling on the paint in heedless abandon.

And I then stand back and realize that the only hope is a glaze of my trusted friend raw umber over the whole thing.

Or something . . .

The Magic Place

Nick and Nina wouldn't tell us their Greek names. They wanted to practise their English, as it was their ambition to visit Britain, and meanwhile they read as much as they could and were well versed in up-to-date English books, as well as newspapers.

We met casually on Nick's home island, where – as he worked in Athens as a civil servant – he was given an extra week's leave every year so that he could return for a visit. This was originally the only way young people could be tempted from their islands to use their talents in the service of the state. Nobody, Nick assured us, would dream of abusing the privilege and spending the extra week anywhere but on the island of their birth.

Though at first our friendship was clearly useful for them in conversation and pleasant for us as visitors, it deepened into one of affection and mutual enjoyment, even though they were the age of our children and we were four completely different kinds of people. We shared the same sort of humour, however, and many of the same tastes and values, and found ourselves playing or dining or walking together quite often as the hot sunny days passed.

One evening Nick said he had planned a treat for us the next day – he was going to take us to his magic place. Nina, round-eyed, said he had never taken anybody there but her, and he had never told anybody about it, and every year when he came back to the island he went there in fear and trepidation in case somebody had found it, but so far it was safe. He had found it as a boy, and, he told us, 'All my dreams were made there. All I wished to do. All I hoped to have. It was there I made Nina in my head, and when I found her in real life I couldn't believe it, and *didn't* believe it until I had gone back to my place and thought about it, and thought about her, and then I knew she was real.'

Nick was short and dark and very plump – three years of Nina's good cooking, he said ruefully. He looked at his own curving stomach, and at Tony's much older flat one, and said mournfully, 'Who would think that I was the descendant of Greek gods and you, Tony, come from mere Norsemen and Saxons.' But he didn't mind enough to resist all the pasta and chips he could get, and Nina clearly loved him dearly just as he was so he hadn't much incentive.

She was small and pretty with light brown hair and a very sweet nature. I soon learned not to admire anything she had, or she would try to give it to me, and a tussle would ensue. A little plastic picnic cup with a lid was all very well, but her scarf – because I commented how lovely it was with her green eyes – was another matter, as was the new Iris Murdoch which she was in the middle of reading, and which I had failed in my attempts to buy before we came away. Her desire to give me these things at once was so strong that I really had trouble with her; 'But I am Greek,' she insisted, 'Greeks like to give. We don't take well but we give well. It gives us so much pleasure – how can you deny me this pleasure?'

There was, however, no question of not accepting Nick's invitation to his secret place, and we received our instructions for the next morning. We were told to wear only bathing kit, and if we must bring anything with us it must be sealed in plastic because parts of the journey would be in the sea.

I did hope not too long in the sea, neither Tony nor I are strong swimmers. 'Shoes?' I asked.

'If you must,' said Nick. 'There's a lot of scrambling over rocks so rubber shoes are best. Otherwise canvas shoes and just wear them wet. Personally I just wear my feet.'

I look questioningly at Nina, who laughed. 'Of course some shoes, though bathing ones are best. All normal people would have shoes – it is quite a journey.'

When we met in the morning we were all wearing minimal clothing. Nick and Tony wore bathing pants and caps, and Tony wore canvas shoes. Nina and I had on bikinis and our hair tied in

cotton scarves, and we had rubber shoes. Tony and I carried nothing, Nick had a well-sealed plastic bag over his shoulder and Nina had a little one hung from her wrist. Our walk took us first over a prickly field, to which Nick's bare feet seemed impervious, and then we began to walk along the shoreline, over cliffs and down on to rocks and sand, and up over the next headland, and down again, sliding on the scree. It was getting very hot so we weren't at all sorry when we came to a place where we had to swim across from one rocky shore to the next, and this we did several times.

Never in my life have I climbed, or scrambled, over rocks for fun, and could never understand those who did. When we were children, holidaying in Cornwall, I was amazed at my mother, who could watch with apparent (I am sure it was only apparent) equanimity as my brothers crawled like flies up the friable dangerous cliffs behind the bay. They clung on, moving slowly and surely up the cliff face between the many memorial tablets to those who had failed to make it. I couldn't bear to watch them. It made me feel as if I had a large ice cube in my stomach, made out of fear. And the idea of my ever doing such a thing of my own volition was unthinkable. Yet here I was doing it, and already, if I turned back, I had a very difficult journey to face so I might as well go on. Besides, how could I opt out of seeing Nick's magic place? Several times, during the last bit of the journey, I wished I had, no matter what the cost in ingratitude and humiliation. The last bit was indeed up a cliff face, and it looked every bit as

60

treacherous as the Cornish rock, even though Nick could tell us exactly where to put our feet all the way. All the same, there was nothing to hold on to. I couldn't even take refuge in the thought that I would after all fall into the sea, because the sea, and the way down to it, was full of rocks, and would not be at all comfortable.

Nina led us, knowing the way perfectly, and Nick came behind me with a stream of confident advice, but it seemed to me that the climb was going on for ever.

I remembered Tory asking, 'Was this the worst moment of your life?' when she and I at last got to the bottom of an endless perpendicular stretch of scree down the side of Sca Fell to Wastwater in the Lake District (a week later a boy, boldly taking it at a run, was killed, so I wasn't imagining how awful it was). I said fervently this was. But climbing up that jagged cliff in the beautiful Greek sun I knew it had been surpassed. (And would be surpassed again, reaching Lycean tombs on a high, high, sheer cliff face in Turkey, with a narrow slippery path to walk on and the young doctor who happened to be climbing with us so terrified that I was afraid of accidentally touching him in case his shaking sent me flying off my extremely precarious balance.)

As we neared the top of the overhanging cliff, climbing up to an aperture like a picture window, there, against the rocky sides, we found little planks to sit on, and a table Nick had made years back (and brought, plank by plank, and erected), and a little shelf on which were stowed beakers in plastic boxes and plates.

Once we were there, seated at the table, looking out over the blue sky and tossing sea from such an unlikely angle, it was worth it. Out of his bag Nick brought wine and bread and Nina had in hers olives, sun cream and antiseptic cream in case anyone had cut themselves. So we feasted in the magic place he was so proud of and Tony and I felt properly honoured to be there as we drank to Anglo-Greek friendship, and wondered about who else, across the centuries, had ever found it.

'I come every year,' Nick said. 'It renews me to be here. I shall remember this year with love because I have shared it with you

and Tony. Only four of us know it now, but you, I know, will never tell.'

Of course I wouldn't. Of course I haven't. It is very hard to find and nobody could search the whole coast of every Greek island, even if I had given any indication of where it is.

I hope Nick and Nina now have children who will be shown the place when they are old enough, and can feast as we did, as if in an eagle's nest, and feel the magic even if it is quite difficult to reach. It *was* magic and it was worth it.

Before the Palio

My passion for seeing new places does not, unfortunately, embrace doing anything practical about getting there. The very idea of purchasing tickets, making decisions and bookings makes me shy in an abrupt curve, like a horse scared by a piece of paper blowing in the hedge. How blessed I was, therefore, to marry a man who positively enjoys all these matters and the research, bother and telephoning and insisting involved.

We would agree, in principle, on our destination and the date of departure, and the next thing I knew the whole thing would be fixed up, and all I had to do was go to the library and come home with all the relevant books required for reading it up, and so begin the pleasure of our coming travels.

Now and then Tony's reasons for picking on a certain place were bizarre, but none the worse for that, such as the time when he picked Samos when we had agreed on going to a Greek island (which gave us a pretty wide choice, after all). 'Why Samos?' I asked.

'For the wine,' he said in a conclusive voice.

'And who said the wine was so good?' I pursued.

'Homer,' he said.

Another time, when we had decided that we must see something of mainland Greece and particularly the Peloponnese, I found to my dismay that he had booked a bus tour, in July.

'But you *like* heat,' he pointed out in reply to my protests.

'Of course I do. I don't mind that, but I *don't* want to see wonderful places like Mycenae and Delphi with thirty other people, and you *know* how I feel about Greek bus drivers. Why would I want to spend two weeks behind one of those?'

He made soothing noises to disguise the fact that he was taking no notice of me, and we set off in due course to wait

in Athens until our coach, containing the other people, would pick us up.

It was a large smart coach and when at last I dared to look at the contents I saw only four people: a boy who had just left school and was going up to Oxford to read Greats – he was our guide – two Irish priests, and another man who turned out to be a Hungarian professor. Nobody else except the Greek driver.

Something had gone wrong somewhere as far as the tour was concerned but it was very greatly to our advantage. The Irish priests were charming and interesting, both classicists, like Tony and our guide, so conversation over dinner in the tavernas where we stayed en route was extremely elevating for me, as I lack both Greek and Latin, and would have been for the professor if he had been faintly interested, only he was not. I think he had come to the wrong country. I don't know where he thought he was but every time we came near a town (which was seldom) he began murmuring about cream cakes.

My horror of Greek drivers was, however, justified, but as we had the whole bus to ourselves I could commandeer the back seat and look out on what we had safely accomplished rather than the hazards ahead. Also I could use it as a changing room, since I was the only female in the party, and we diverted the bus whenever we saw the sea, and had a swim. We could do exactly as we liked, and five of us all liked the same thing, leaving the sixth to slump in his seat muttering about cakes as long as he liked.

I felt the same trepidation (clearly being rather slow to learn) when I heard we were going to spend a holiday near Siena in an apartment in the garden of a large country house about 3 miles from the town. When I read the details, after it was all arranged, I said, 'But it is the tool shed.' 'Nonsense,' said Tony. But it was. Admittedly the half prepared for us was extremely nicely done. Bedroom, sitting room, bathroom and tiny kitchen, all very well thought out, so no doubt the mowers and rollers and spades and rakes were equally well cared for next door, and they didn't really impinge except for the oily petrol smell which hung in the air. Even

that had competition, however, from the variety of exquisite scents from the garden, particularly at night, which had first impressed me on our exhausted stumbling midnight arrival.

Owing to roadworks and diversions we had arrived so late that the villa's owner, a rather up-market Sienese lawyer, had locked the huge iron gates of the estate and gone home, leaving a notice to ring him when we arrived. There was of course no telephone, or local house even if we had felt like waking strangers up at such an hour, so we had to retrace our steps to a café on the road a couple of miles back and ring from there. Signor Umberto then came at last, bearing a key a foot long, and opened the vast gates, telling us to leave the car in the courtyard – not that we could see a courtyard. All was pitch dark, save his small and wavering torch – because the rest of the way was on foot. So we followed as best we could in his wake, in the scented black-velvet night, for about a hundred yards, until his torch shone on a keyhole, and he opened the door for us on our excellent tool-shed quarters.

Among the bedroom furniture was an old-fashioned hatstand, which quickly proved absolutely invaluable. Why don't we all have hatstands? They take up so little room. Ours, in no time, was hung with clothes, sun-hats, wet shirts on hangers, towels, cameras, painting bags, jackets (wet or dry, and we had plenty of wet days) and even wet espadrilles impaled on its horns.

When we woke on the morning after our arrival and could appraise our surroundings we were enchanted. We were in a vast and beautiful garden with acres of wide green lawns (mostly clover and lovely to walk on with bare feet) sloping away through rose hedges to wonderful views on all sides. Nearby the enormous and splendid villa rose in all its ochre majesty, empty now until the Palio when Signor Umberto would bring many guests. For their entertainment there was a little open-air theatre at the far end of the lawn, and beside it a plinth bearing inspiring passages from Beaudelaire about flying one's soul's song skyward and that sort of thing.

The air was all scented with genista, and we were alone there. During our stay we very occasionally glimpsed a gardener, and

once a woman brought us some post and clean linen and towels, but otherwise we had fortuitously timed it exactly right, leaving just before the Palio, so we saw all the amazing, wonderful, rehearsals, but not the dangerous race. The day before we left, the villa was opened up. Our host and his guests strolled the lawns in caftans and other exotic garments, and lay about on long chairs smoking and drinking, and we knew it was time we went. The garden was no longer ours, but what a joy it had been.

I'd had an abundance of painting time there, and elsewhere – poppy fields, farms, olive groves, people in the street in Siena, though street life there is limited, by Italian standards, owing to the narrow streets between tall cliffs of houses, so that one has to flatten oneself against the walls when cars pass.

Looking from the garden towards Siena, the city rose peach-coloured on its distant hill, and the same warm brick colour appeared intermittently across the greens of the landscape between, in farms and vineyards, so that there was blue-green and yellow-green and brown-green with these dashes of terracotta, and the dark exclamation mark of cypress trees at regular intervals, and swathes of silvery olive and blue hills in the distance. All we needed was a deep blue sky and long shadows, and there we were out of luck. It did mean, how-ever, that we were assiduous sight-seers and used all the guidebooks we had brought most thoroughly.

Before we left home we had had a telephone call from a farming, ex-army friend. 'Where are you going? Italy? Won't it be very hot?'

'Well, we hope so.'

'Do you? Good God. Well, enjoy yourselves, though Lord alone knows how you can if it's hot. Don't get skin-cancer.'

He needn't have worried. Hot it was not, but as the promised nearby swimming pool 'available for all Signor Umberto's guests' turned out to be in a tennis club half an hour away and temporary membership cost £100 ('only a small sum, nominal,' our host had told us when we asked about it), it was as well that we had not optimistically joined when we first arrived because swimming was not, in the event, on our minds. So we explored Perugia and Orvieto and returned to Florence where, having observed that everyone, but *everyone*, that summer was wearing crumpled white linen shirts, and having resisted the idea personally on the grounds that crumpled shirts only looked good on people with completely uncrumpled faces, I was enchanted when Tony presented me with my own beautiful Italian linen shirt, pure and white and soon properly crumpled.

In Perugia we were thwarted in our attempts to get into the cathedral. It was being cleaned and repaired and was wrapped in canvas and scaffolding. There were certain things in it we had long wanted to see so it was very annoying. We walked round and round it trying to get in, in vain. Finally we went through a beautiful archway leading to the cloisters and in the wall backing the cathedral there was an open door labelled 'Radio Augusta Perugia'. Tony went up the marble staircase inside this door to ask Radio Augusta – and vanished.

I waited in the marvellous cloisters, the centre filled with builders' clobber, and a few of the builders' cars. How had they got there? I couldn't see any access. The entrance was a steep flight of upward-edged steps, in the Perugian manner which I hadn't seen before, but even if the cars had managed the stairs how had they edged between the pillars in the centre? Well, somehow they had . . . and where, after such ages, had Tony got to?

It was a very long time before he returned, looking like the cat that has swallowed the cream. 'Come and see,' he said.

I followed him up endless marble stairs, past the silent and closed office of Radio Augusta, and up more and more stairs until we came to an old wooden door in the wall. He opened this and we went on up, interminably up a spiral staircase until we came to

a tiny door in the wall, went through this, and there we were, up on the cathedral roof and looking down on the entirely scaffolded building. No wonder they wouldn't let anyone in. So we only caught a glimpse of the stained glass shining between the scaffolding. And then one of the workmen, far away but on our exalted level, saw us with clear astonishment, and not wishing to push our luck, we instantly vanished.

Returning at the end of the day to the tool shed, we sometimes saw Siena in that wonderful last light which intensifies all the colours, and the buildings became rose-red and apricot as little golden lights began to glow among them. It was always a delight looking across at the distant city, on its hill, at first light and last light, it appearing to float on swathes of morning mist, or looming, Monet-like, in pale washed colours through a screen of rain. My many attempts to paint this magical view were vain but pleasurable, and helped to imprint it on my memory.

The days we spent in Siena were rewarding except – for me – the cathedral. I remembered how much I had disliked it previously, but hoped to find myself cured of dislike – and I wasn't. I knew it was very clever to have built it, six-hundred years ago, so elaborately, but that was no reason why I should like something so much the opposite of everything I *do* like.

All those zebra-striped pillars, some with wide stripes and some with narrow, and all so insistent that you never know where you are, only that you'd rather not be there. The floor of marble pictures and patterns, and rising from it arches and sections and ribs all carved out of their minds, and in between those, frescoes in every space, and overhead blue sky and stars painted on the roof. The eye recoils from the black and white dazzle and finds not an inch on which to rest – and all this after an initial encounter with the façade, whose fierce black and whiteness is too much to take in, like trying to visualize what a trillion is.

There were, of course, treats as well, such as the Pisano carvings on the pulpit, where the passage about the slaughter of the innocents is almost unbearably moving. The children so trusting,

the soldiers so casually cruel and the mothers so anguished, and all so immediate and expressive, albeit in cold marble relief.

We also managed to get into the Public Archives, which sounds so dull and is anything but. We climbed stone stairs for seven floors in a building at the bottom left-hand corner of the Campo, till a balcony window showed us that we were already far above it and we looked down on midget people scattered on the cobbles moving like beads on a tilted tray. Then we went through room after book-filled room, all books, floor to ceiling, the first few in vellum and parchment and later in linen and paper. At last we reached a little room where the covers of the city account books from the twelfth century onwards were displayed. The oldest ones were panels of wood, later they were painted leather or wood, and still later the scenes they depicted were simply small detailed pictures, oil paint on wood. The ones we liked best were the office scenes – council workers queuing up to be paid from the stack of gold coins on the counter, and one staggering away with bent knees, barely able to carry all he had earned. The long narrow chests in the background which were the filing cabinets, and earnest secretaries keeping careful note in giant ledgers, their legs colourful in two-coloured hose and long pointed shoes.

Later, in Orvieto I was able to wash the frenetic image of Siena's cathedral façade from my mind, as we gazed in delight at the one it had to offer. Just as complicated, but light and airy, glittering with gold and jewelled mosaic all down its twisted columns and the subdued but rich colours harmonizing with the honeyed stone of the town. Lorenzo Maitani spent virtually all his life on this magnificent work, and few people can have achieved such a lasting memorial. For all its elaboration, it was peaceful and beautiful.

When we returned to Siena, it was time for the evening *passeggiata*, and it was a pleasure to walk through the decorated streets – each guild, or contrada, having its own colours and symbols. The members of the contrada remain loyal and enthusiastic, much of their social life based around the contrada church, though there are only seventeen contrade now compared to the sixty operating

when Siena was an independent republic. Of these ten can take part in the Palio, the left-over seven forming the base of next year's list of runners.

We had walked through streets hung with crimson and pale-blue silk flags, belonging to the Torre contrada, and then in dark blue, yellow and red for the Nicchio, with shell-shaped lamps to match their name. Flags and banners hung from all the windows and across the street (the shell lamps soon outdone by scarlet and gold flaming torches) and when we reached the Duomo, silver dolphins crowned with little lights. We were now in the area ruled by the Capitani dell Onda, and the flags and bunting were all beautiful cerulean blue and white, and in the streets people were wearing these colours. Babies sailed by in push chairs beribboned in blue and white, and one little child in a tiny little parti-coloured shirt waved a matching flag, and wore one blue shoe and one white. The houses opposite the Duomo on the other side of the square looked particularly splendid, with long crested banners waving from the windows in one, and long swags of blue and white, from window to window, in the next, while the third had burgeoning window boxes, the blue flowers all of the exact, and most unlikely, shade of blue, clearly some poor innocent white marguerites carefully and precisely dyed.

Something seemed to be going on there. People were hanging about on the steps, and men were beginning to assemble in the square, dressed in beautiful quartered tunics, with formal white waves appliquéd on the blue parts, striped hose, and Robin Hood hats in blue and white, and splendid medieval-style suede shoes. They held huge silk flags, half white and half blue, and always with one corner picked up while being carried. When about a dozen of these decorative men had assembled, they stood about in little groups, chatting and having a final cigarette, while some already practising with their flags, whirling them above their heads, throwing them into the air and catching them neatly as they fell.

Wives, girlfriends and children stood on the steps, small children darting down now and then to claim a kiss from a glorious blue-and-white papa, but they were all hurried away from the square when the

sound of distant drumming became audible. As it came nearer and nearer, it was very exciting, and at last the drummers came into view, four of them, heading a band of twenty or thirty men, and when they had halted in the square, those already present fell in behind them and the flag-flying began in earnest. They flew about in a figure of eight, and then high into the air, as high as the second-floor windows of the houses opposite, and not one missed its mark as it fell. This breathtaking skill, I later learned, is called alzata.

The drumming became more and more intense, and before long an echo was discernible, and from the right, between the houses, another four drummers and another marching contingent appeared, but this time they were all boys aged from about seven to thirteen, dressed exactly as their fathers and uncles and flourishing their own scaled-down silk flags with which they were clearly just as adept. Then four men and their flags mounted the steps beside us, and four drummers, two men and two boys, and all the rest of the square – it looked like the rest of the world – was filled with blue-and-white men and boys and flags.

The sound of the drums became louder and louder – dar-a-dah, dar-a-dah, dar-a-dah-dah-dah – and the flags whirled faster and faster and were flung into the sky and caught again until the whole universe seemed full of drums and movement and flying blue and white . . .

If at that moment someone had said, 'Come forward now and declare yourself for Christ!', I would certainly have done so. All the people on the steps with us were carried away, laughing, crying, calling out, children jumping up and down and shrieking and hugging each other. Our fellow watchers were almost exclusively women, since all their men were so magnificently performing. There was the occasional grandpapa, but the rest were the wives and girlfriends and sisters of participants, shouting and clapping and calling encouragement into the sky-high sea of spiralling blue-and-white silk.

How long would it last, I wondered, this age-old ceremony taking place that evening all over the city under different flags as

every district had its final rehearsal for the Palio? With no recognition of the equality which so preoccupies us nowadays?

The Campo was all prepared, fenced off, tan laid on the track, tiers of seats covering the rest of it, and horrific stories were being flung about with reference to the prices tourists were being asked – and would pay – for last-minute tickets.

For the second time, we would not be there to see the race and we were not at all sorry. It is a great night for the Sienese, with far-flung family members all flocking home for the Palio, but we had delighted in the decorations and preparations, and been exhilarated by the highly charged Contrada dell Onda rehearsal, and were happy to leave the race itself to the people of the city.

Sunday Best

Tony can't pass a church without wanting to go in and see what it is like, so we have spent a considerable part of our lives, in various countries, hunting for whoever has the key of a locked church. Trying to find one in action on a Sunday is even harder.

We did locate one in a village in southern Italy, and turned up at the proper time, summoned by the tinny evocative sound of a single Italian bell. Women, mostly exceedingly decently dressed in black, were all going in, while the men were all gathered in the village square, talking, smoking and in some cases, arguing loudly.

We followed the women in, and sat discreetly at the back. In came the priest, and an altar boy in a T-shirt emblazoned with Superman, and the Mass began. That, it seemed, was the signal for the men to come in, in a herd, still talking and very noisy.

We had wondered why the women had all settled on the left of the aisle. Now we knew. The men all sat down on the right, taking their time to do it. We, sitting together, were clearly in the wrong and that was made plain. Everyone there turned, at one time or another, and stared unwelcomingly at us. One or two men jerked heads or thumbs to indicate to Tony that he was in the wrong place. We had no wish to offend anyone, so, to pacify them, he crossed the aisle and we sat with its dusty width between us; honour was satisfied.

On the way out both sides of the aisle greeted us politely so we had clearly been forgiven, but it was an unusual service, to say the least.

In Nerja, in Spain, we felt we had done well in locating the church (which, being a not very appetizing modern one, Tony had no wish to explore) and therefore finding out the service times

73

well ahead of Sunday. Of course, when we arrived at the time stated on the noticeboard we found the service almost over, but that was just as well because, though it was a small church, a microphone was used at ghetto-blasting volume and the noise was formidable. Inside, the dull little church was rather nice, with bronze bas-relief sculptures on the white stucco walls, and the responses from the congregation sounded normal. Then the priest's voice would crash out, shaking the very foundations and battering one's eardrums, and one could see the congregation cower before it, like a field of wheat flattened by gusts of wind. It was all perfectly ridiculous because it was not necessary to use a microphone at all in that small building, adequately filled with about forty people.

When it was over, and after the booming blessing, a young man went to the lectern and poured into the mike a torrent of words for ten minutes without note or pause, at such volume and speed that I couldn't make out one single word, or even be sure what language he was talking. When at last he stopped he ran down the aisle and out into the sun. All very confusing.

Fortunately, an American woman then rose in her pew, and in slow and careful English, for the benefit of the few foreigners present, explained that as the young man had talked so quickly we might not have understood him, and she was sure we were all concerned about the plight of victims of AIDS and would contribute all we could to the cause. We were very grateful for this helpful intervention.

One place where we were completely foiled when it came to church-going was the Alhambra. We stayed in the only place one can up there at the top, bar the Parador San Francisco, which is the fascinating guest house one has to book years ahead. When you get there you wonder why on earth this is so, until you find the clue: it is completely and undisturbed Henry James. I was quite relieved that the tiny room we had booked so prudently and so very long ago was near the ground floor, because there was a notice on the door relating to fire precautions. It read:

1. In case of fire telephone the office telling where fire is.
2. Do not shout or run about.
3. The nearest exit is – m. on the right/left.
4. If you cannot make escape, stay in your room stuffing wet cloths at door cracks.
5. The nearest stair is – m. on the right/left.
6. Go to window and tell people you are there.

I imagine one would.

The blanks on the instructions were doubtless because there *was* only one staircase, and luckily for us, we were near it.

There were, even without churches, many advantages to being in the Alhambra in the evening when all the crowds of visitors had gone. I enjoyed the afternoons, too, when we had done as much exotic and overwhelming sightseeing as we could digest and, while Tony had a siesta, I hid in an alcove of the beautiful Generalife gardens and painted. I have since read that this is one of the most dangerous places in Europe, and that all sorts of crime flourish in the green walls and alcoves around the watery stairs, but, unaware of this, I painted contentedly and invisibly, much enjoying the snippets of conversation I overheard as people walked along the path behind the hedge at my back.

'*Tu es le diable*,' whispered a fierce French voice '*C'est vrai, le* diable,' and the rest of his fury was unluckily out of ear-shot. Then an English female insisted, 'Arthur, don't worry. All will be revealed. All will be revealed.' What on earth was that about? I longed to know. Had some rich friend subsidized the trip and was now behaving oddly?

A young father insisted, 'No. You either ride or push. We're getting nowhere like this. I said you either ride or – oh, very well, but don't get under my feet then.'

A north-country voice complained, 'It's not as if they did anything *for* it, is it? I mean we could all behave like that if we had the brass neck, couldn't we?' and an American said, 'Well, what they were complaining about was not enough ratio of women to guys.'

Unfortunately for me, a Japanese tour guide peered into my alcove and spied me. I can only suppose he suggested to his flock of thirty tourists that each should stand beside me, hand on my shoulder, and pose for a snapshot while I waited, brush poised, for them all to clear out of my view. For that is what they did, each in turn posed while the other twenty-nine took a photograph. It was as though I were a gatepost or an urn or something, so completely did they ignore me except as a prop. The last one, to do her justice, did make a little bow as she left, and then they all chattered away and I could at last resume my painting. It is an odd thought: my patient figure, my easel and paints and canvas, all faithfully recorded in thirty Japanese albums.

I had forgotten it was Sunday, so my painting was interrupted again by Tony arriving and saying we would have to go down the hill to Granada to find a church. It was by then raining and the only protection we had – well *I* had – was a rainproof jacket and a folding umbrella. Since he was insistent on going we did our best. He wore the jacket (and very peculiar he looked as it strained to bursting across his shoulders and the sleeves ended half-way down his forearms) and I had the much more effective umbrella.

So we zig-zagged down the hill, through the dilapidated houses – dilapidated because Napoleonic law obtains in Spain and nothing can be done about a house in a perilous state of decay until old Aunt Ena can be located, or Cousin Joseph, who lost touch with the family forty years ago – and came to the baroque church of Santa Ana, where there was a service in progress and they had just reached the first lesson. That didn't matter as in the continental and very un-British fashion, people came and went all the time. It was a very good baroque church; masses of brilliant gold curlicues on a soft dove-grey, and nothing solemn or heavy or discreet. But again the amplification was shattering, and this time it had to compete with a gypsy band in the square outside, all too audible through the open doors, so we emerged at the end with battered senses and feeling rather as if we had been at a rock concert. Since we were in the town, we then went on to the

cathedral, where people were clambering all over the place, over the tombs of Ferdinand and Isabella, and up and down the steps to the high altar, taking flash photographs and not being in any way reverent or orderly.

Through a locked door, however, we could hear a service in progress and this was too much for the insatiable Tony. We went round and round the cathedral till we found the way in. This time they had got as far as 'The Peace' and, in spite of my reluctance to sit through another Spanish sermon (never mind gaze at dark nightmarish pictures of tortures suitable for straying friars), Tony sat down firmly.

Fate was on my side, however.

The gypsy band was clearly doing the rounds of the churches and now it was the turn of the cathedral and its conveniently open side door. I felt very grateful to them.

We did manage, when in Venice, to get into St Mark's at the right time, though we had to swear to several officials that we did, really, truly, want to attend the service. Even without all but the most basic Italian (Tony has Latin, which is a great help), we could canter after the order of service quite well, even though I couldn't imagine why the sanctus bell was rung at those particular times: it seemed to make no sense.

However, it was all exceedingly beautiful, taking place among the golden vaults and heights, and we came blinking out into the sunny square, to find crowds gathering and barriers being put up all the way to the quay. We asked a policeman what was going on and he told us that 'The

Lion of Venice comes in one hour.' Having only arrived the night before we hadn't noticed that the left-hand column was minus its lion. He had been down for months, for repair, and was arriving by sea, to be brought to the Doge's Palace while scaffolding all up his column was prepared to hoist him up.

When 12 o'clock struck (an hour later than predicted) and seething crowds remained happy and cheerful, passing ice-creams to their beautifully dressed children, and somehow remaining clean and beautifully dressed themselves while doing so, all the very smart policemen and men with walkie-talkies and the press began to position themselves by the quay. Presently there was the sound of drums, and along came drummer boys and men with trumpets and horns, dressed in exquisite fifteenth-century-style clothes, all velvet and tights and pointy shoes. They were followed by the mayor and city dignataries, among them a very few female members, in exceedingly short skirts and exquisitely done hair, so smart, so high-heeled and so well-coiffed. Then there was a long, long pause . . .

. . . For forty-five minutes or more.

It became clear that the lion was reluctant to return home. We could just see, from behind our barricade, a gang of men in matching T-shirts bumbling about down by the quay, and the lion's stationary wing-tip, but obviously he wasn't going to move. It transpired that the wheels of the platform he was on were far too small to cope with the paving, so we had to wait till a frantic man with a little truck brought sheets of plasterboard, and these were laid in front of the lion. Then he was hauled and pushed and shoved, inch by inch, by a dozen sweating men. He came slowly round the corner. He was as big as a bus and wore a wide meaningless smile and the tip of his gigantic tail rested on a block of polystyrene. It took an amazing amount of time for him to progress to the palace, his escort racing ahead to re-lay the boards as soon as he had passed, and the dozen porters struggling to move him a fraction at a time.

However, the crowd loved every moment, as we did. Nobody seemed to be saying, 'Why didn't someone work out the logistics?',

or 'Why did they fit the lion's trolley with wheels which would have been inadequate on a baby-buggy?', or 'Why didn't they make sure the ropes were strong enough?' – which they weren't. One had broken during the first ten minutes, and there seemed to be no spare rope to hand, so that made for another long pause for which the porters were doubtless grateful. Certainly we joined everyone else in thinking this was a wonderful way to spend a large part of Sunday.

Nobody was in a hurry, nobody impatient or worried, and the lion moved past them at a reluctant snail's pace, wearing his unchanging inane smile.

We were relieved, however, to know that we would not be there ten days later to see him hoisted on to his column. If those in charge of him had such difficulty getting him over flat ground, on wheels, how would they ever get him up there?

We were therefore thankful, later, to read that it had been accomplished, but I am still glad not to have been there to watch. I think the strain of watching that last step, knowing what could happen if yet another method was wrong, would have been unendurable.

Patara

We were not without ambitions but they didn't always work out. A painting holiday in Kashmir, with a much-admired tutor, sounded too good to be true. And so it was. We were all safely booked in, and then heard it had been transferred to Nepal, so with much changing of dates and cancelling and altering various engagements, we rearranged our outlooks for Nepal and began to buy and read appropriate books, since we were no longer to be in Rumer Godden country.

We were all set to depart for Nepal on the 27th when, on the 25th, that place was also deemed too dangerous to visit and the holiday was cancelled. The Kashmiris had at least only shot each other, albeit quite a number of each other, but the Nepalese in their enthusiasm shot tourists as well, imposed curfews and closed airports so there really wasn't much option.

With great dispatch, Tony seized the only travel brochure we had left in the house (all the others had been thrown out; we had our hols all fixed up, after all) and spent some time on the telephone. He then announced we were going to Patara in Turkey, though April there was rather early for us as we love the heat. Patara, he declared in triumph, was the birthplace of the fourth-century bishop, St Nicholas, known to us as Father Christmas. It seemed a good reason for going there.

When we reached Patara, and found ourselves in a new – in fact, half-finished – hotel sited on a hillside above the village, the sun blazed merrily enough, but a cold, fierce wind blew non-stop. The terrace where we had breakfast, by the (empty) swimming pool, had been built so as to be a wind tunnel with no shelter, so it was extremely uncomfortable, even though we and our half-dozen fellow guests wore all the clothes we had brought.

Patara, we were told, always had a breeze. *Breeze*, for heaven's sake?

Our one aim, wherever we went, was to get out of the wind if we possibly could. We chose the restaurant in the village solely because it had thick plastic sheeting round its terrace. Never mind what the food was like. (It was, of course, good, as it is mostly in Turkey.)

The chilly windswept breakfast in the hotel on our first morning consisted of a plate of olives, with a slice of tomato, a pat of butter, a bit of feta cheese, honey for each of us and some very nice bread; and when we had eaten that we were each given a tiny boiled egg, not much bigger than a quail's egg but very fresh and welcome. After which, we set forth to try to find the sea, said to be 2 kilometres away. It was nearly twice as far, but no matter as it was a pleasant walk and when we reached the sea neither of us felt in the least tempted to swim in the grey tossing waters, with white horses of foam rearing their heads 2 metres in the air.

What drove us away from Patara after a few days was not the wind, nor the scramble down a steep scree path to the village for dinner, but the lack of water. For the first day there was scalding hot water in the shower because there were solar-heated tanks on the roof, but no cold. On the second day the cold came on for an hour at 5 p.m. On the third day even the hot water had run out – not that it is possible to shower in boiling water – because a pipe had burst and four villages were arguing about whose responsibility it was. Also, since Ramadan was just over, everyone had celebrated so well on Sunday that, added to the Ramadan exhaustion, they had not yet begun to make decisions, never mind get to work on them.

So we went on to Kalkan, which we had not considered as there was no swimming, but by now we didn't care about that, only to have a decent shower and get out of the wind.

The wind had died down a little on our last waterless day, and we walked through wheat fields whose borders were brilliant with flowers. Masses of marguerites whose Indian yellow centres stain

the base of each petal, poppies and scabious, and anchusa and purple vetch thrusting through a sort of many branched buttercup. We were aiming for a Roman theatre, half silted up by sand, and were much surprised, since we had seen nobody for the last half-hour on our way, when a man appeared and asked us for 2,000 lira, and then tried to be a guide with almost no English and less French. We later found that he and a taxi-driver mate lie in wait in a nearby lane, and can spy eager tourists trekking across the fields from afar.

When we had rid ourselves of him, we had a splendid morning, sheltering in a deep stone doorway, which I painted while Tony read the guidebook, before continuing on our way.

On a small wandering path, we came to an exquisite fourth-century BC tomb, all carved and engraved, standing alone and almost as good as new in the flowery field. There were two men there. One, dressed as a pirate, was standing watching, while I thought the other was hacking at the wall with an iron bar, though he stopped as we approached and put his hand behind his back. They drifted off as we lingered to examine the tomb, and were nowhere to be seen as we presently went on down the path. But I was worried. Tony was ambling along, deep in the guidebook, reading out snippets, and didn't notice when I left him to speed back to the tomb and reassure myself that it was safe. It wasn't. The men were there, the pirate on watch (though he didn't see me arriving silently behind him) and the other one prising out carved stones and putting them in his bag.

'You shouldn't do that,' I said priggishly. They were both startled, but seeing only me, snarled and went on with their work. 'It is simply vandalism,' I said. The pirate stood in front of me, sneering. 'And what can you do? You don't know our names.'

'I can draw you,' I said. 'I can draw you exactly *and* your bag and your tools.' They looked at each other and the man with the bag shoved the stone back into place and came away from the tomb. They were Germans and in a thick accent the pirate yelled over his shoulder at me as they left, 'What about all the things you

stole from Turkey and now have in England? What about that?'
He trotted after his friend, then shouted back, 'And what about
the Elgin marbles?'

I was hurrying after them because I wanted to catch up with
Tony – who was still deep in his guidebook, wondering only
faintly where I had got to – and to my delight realized they
thought I was chasing them, so they broke into a run, charging,
panting heavily, past a startled Tony on the path ahead.

No doubt they went back to the tomb when it was safe to do
so. Turkey has so many antiquities, and can't guard them all.

We lunched at a taverna near there where the landlord's
daughter, aged about five, with amazing copper-coloured hair,
came to watch me painting. She asked if I could paint her dolly –
an awful creature who babbled Turkish baby talk whenever a
dummy was stuck into its mouth – so I did, but as I had done it on
the back of my real painting I couldn't give it to her. So, instead,
I took a fresh sheet of paper and painted her and, though it only
took about fifteen minutes, it worked and I don't think I have ever
given a more appreciated present. Old ya-yas were summoned
from back premises, cousins came running, everybody crowded
round her and her piece of Bockingford watercolour paper, and
her father came to say he was sorry we had already paid for lunch,
and please come again tomorrow as his guests. But by then we
were in Kalkan.

We stayed in a very nice little hotel at the top of the steep village
which plunged down to a sea of amazing colours, of deep blues
and greens, and a little yacht marina, where it was very diverting
to watch in the evenings when various craft berthed for the night
and their crew came ashore for Kalkan's excellent restaurants.

The roof of our hotel was the bar, the dining room, the lounge,
whatever. All round the edge was seating with snow-white
cushions, and there were white cushioned chairs at the shiny
brown tables and a snow-white tiled floor, so relieved to be warm
and clean and comfortable in our nice little room, we went up on
the roof to read in the blissful sun. The manager was busying

himself, organizing tables, putting out bottles in the bar, and I said I hoped we were not in the way. 'Not at all, Mrs Trollope,' he replied. 'Please regard it as your home. It is indeed your home as long as you are here.' It would be so nice if I kept my home as shining and immaculate . . .

The manager set the tone for everyone we met in Kalkan. They were all kind and friendly, but surpassed themselves on our last night. The baker's daughter was to be married and the celebrations were due to take place late in the evening in the harbour. We walked along the concrete path curving round the bay to the best restaurant of the several good ones, and had a splendid dinner which lasted until we could see the lights and hear the wedding music floating across the water.

It was pitch black as we left the lighted restaurant so we never saw – and didn't remember – a steep concrete step down. Since we were walking along entwined we fell over in a block, like a chest of drawers, and it was as well we had no time to put hands out to save ourselves, as we would certainly have broken them. I was up again in a moment but Tony lay where he had fallen, face down on the concrete. 'Oh, do at least *groan*,' I said desperately into the blackness, trying to feel which bit of him was where. So he did. That was all right then. He was not only alive but responsive, but what to do next? Nobody was about. If I shouted it was doubtful I would be heard. Music was playing in the restaurant 100 yards behind us, and at the wedding 200 yards ahead, and the wind and sea were also in competition. I just had no idea what to do. Tony was too heavy for me to lift, and I was still trying to find out what he could move for himself when there was the sound of running feet, and a voice saying, 'OK, OK, I come.'

Two young men suddenly jumped down beside us. How they knew what had happened heaven only knows as we had made no sound, but perhaps visitors are constantly falling down that steep step so that they keep a look-out. Anyway, they couldn't have been kinder and more gentle with Tony, who was by now beginning to stir. They had a torch, so we could see his considerably grazed face

but it did seem as if all the rest of him was all right, only – and understandably – shocked. They helped him to sit up, and then, presently, stand, and they supported him as we made our way back to the village.

Slowly and carefully, we climbed the hill towards our hotel and as we reached the café in the centre of the village, the young men suggested that Tony should sit down and rest and have a brandy. This was a good idea and I was sorry they would have no refreshment with us, but I suspect they were on their way to the wedding, so they vanished, followed by our most heartfelt gratitude.

'Are *you* all right?' the recovering Tony asked somewhat tardily, and I said I was, though I mourned the slit in the knee of my beautiful silk trousers. The slit in my own knee would soon mend, though the blood was still dripping into my sandals, but the same could not be said of my valued trousers. The waiter at that point was serving our coffee and brandy, and he said, 'Lady, the tailor will mend trousers', which was a kind idea but no good because we were leaving at eight in the morning.

'No, not morning. Now,' said the waiter. 'I fetch him.' It was by then 11 o'clock, but in a few moments the tailor came, took me to his shop and a basin where I could wash my gory knee, gave me a bandage to restrain further damage, lent me a pair of trousers to wear while he mended mine and escorted me back to the café table. In less than an hour he returned with my trousers, washed, ironed and bearing a mend so exquisite that it was an ornament. He had drawn threads from the fabric so that all one saw were a few zig-zag lines, very faint, in some lights. In most lights it didn't show at all. The charge for this was the equivalent of 45p.

Looking back, I am not at all sure how much, or if any, English was spoken that evening. But it is amazing how much communication can take place without a common language and especially when human qualities of need and kindness are involved. It is no wonder our thoughts of Kalkan are all so kindly.

It was from there that we went one day, in a minibus, with four other people and an English guide, up and up and up on a dirt track

into the mountains for an hour, past the snow line until suddenly we were looking down into a fertile valley spread far below us, perfectly flat. No foothills or outcrops, just the mountains stopping abruptly at the edge of the neat emerald green fields, tidy orchards and rectangles of ploughed red earth. There was a village scattered across the middle of it, looking like a tiny toy one so far away.

This valley was impenetrable in winter until four-wheel drive came to its aid; before then nobody could get in or out, all winter long, except for the occasional very fit and hardy man, so the villagers had become completely self-sufficient. They grew enough food, had their own mill and tannery, quarried stone from the edges of the mountain and had plenty of wood to make chairs and fires, and wool from their sheep and milk from their goats and cows. Latterly, a lot of villagers had migrated to Kalkan for the winter and still kept houses there, so, even if they elect to stay in the valley now that transport is easier, they are sitting pretty because they can let their other properties to tourists.

When we arrived in the village we sat on very homemade chairs on a dusty verandah and we were given sage tea, which we found peculiar but not horrid. Next, horses were brought to convey us for the 4- or 5-mile tour of the valley. We'd been warned about this and I had callously thought, 'Well, that's all right, I can ride and I expect Tony will manage.' But very soon my hard heart had its come-uppance.

The horses did not have saddles but contraptions like wooden howdahs, with a narrow slit between two high semi-circles. One had to slide into the slit, doing the splits, unable to move one's pelvis a single inch, and of course men had far more obvious and worse disadvantages. Tony was the only man in the party and his pony was led by a very tiny wrinkled old man (who was, in fact, a mere sixty-one), so it didn't matter that he couldn't ride. It did matter, however, that he couldn't move from his painful position, and he is not in any case used to having his legs at right-angles to his hips, so he got off after ten minutes and walked the rest of the way. I wasn't at all surprised.

He was rewarded, however, when we paused at a farm that had been alerted to lay on some lunch for us. The farmhouse looked like a tumble-down shack with the family living upstairs, reached by a ladder, and all the animals underneath. It was surrounded by a rough orchard, and there, under a tree, was spread a large carpet and some embroidered cushions and at one side a mattress and pillows covered in snow-white linen, lavishly trimmed with lace.

There were three little girls in the family and one of them brought a large can of water and a towel and we all washed, and then they began to bring a succession of dishes. One exhausted member of the party, Sylvia, sank down gratefully on the snowy mattress, at which the farmer's wife squawked in dismay, telling her to get up at once. Red-faced and bewildered, Sylvia did, and the explanation soon came when our hostess approached Tony, and with great politeness indicated that the mattress and all the lacy pillows were for him. So Pasha Tony had no option but to recline there while Mrs Hassan offered him plate after plate of food (our food was just put on the carpet for us to bag before the hens did), which the little girls brought down the ladder from the house. Huge plates of spinach bread, unleavened so it was like spinach pancakes, and yoghurt to dip it in. Cubes of cheese. Plates of olives. Hard-boiled eggs. Boiled potatoes – and a little plate of chips for the Pasha. And a thin salty herb-flavoured yoghurt called *kan* to drink. We finished with green almonds the little girls picked off the tree for us, which we were required to eat the whole of, the velvety green husk and the soft juicy nut inside. I ate mine with difficulty but it was an experience.

All the while we were absorbedly watched by the three children, a handsome cock and all his hens, a cat and a goat and a rather puzzled dog.

Then everyone went to sleep for half an hour (the Pasha most comfortably on his mattress and pillows) and I painted the cock, and all our attentive audience watched me paint. When I had finished I showed the painting to the nearest hen – who was very tame and didn't flinch – and asked her if she thought I had caught

her husband's expression. She just looked back at me with her round hen eye, but the little girls all collapsed in heaps of laughter on the grass because they realized what I had said.

So I did a swift drawing of each as a present and they scrambled, shrieking with delight up the ladder to show their mother who appeared in the doorway wiping one of the big platters. How did she wash up there? In what? There was a pump in the yard but no sign of water pipes or drains that I could see, and yet all the endless dishes had come down the ladder and went back up it and somehow or other got done, and her clothes' washing at least was extremely effective, if the Pasha's beautiful blindingly white linen and lace were anything to go by.

Bangkok and Singapore

Towns, villages, nations, people and gardens are all changing all the time and nothing can be done to stop this organic process. When, now and then, a beautiful village tries to keep itself unchanged it doesn't work, because the life force dies and nothing can breathe in the sterile air.

So it is pointless to mourn that such and such a place has been destroyed. It is sad, very sad, but rather than dwell on the sorrow of it, it is a better use of one's time (and life) to enjoy what is left, particularly if it is new to you.

Since every one of us is unique, so is our response. Thousands of people must have stood in awe before *The Winged Victory* but how did *you* react to it? How did I? I have long been grateful for the reproof I had from a wise man when I was having the usual annual moan about the quality of the Royal Academy's Summer Exhibition. He said, 'You are doing it all wrong. You should enter each gallery and find a painting you like. There may be only one. There may be two or three. Spend all your time on your chosen painting. Time is limited and you will be well rewarded if you use if to study a few decent paintings and simply close your eyes to all the rest.'

I think the same sensible advice can apply to new places or countries; even if you spend a long and exhaustive time there a selective eye will give you a good starting point.

When Keats wrote home to his parents in 1819 he remarked that, 'Nothing ever becomes real till it is experienced – even a proverb is no proverb until your life has illustrated it', and travel is a very good example of this.

Before we went to Bangkok we were told how awful it had become – noisy, wicked, seething with uncontrolled traffic and drugs, exploited and exploiting.

Probably so, like many other places.

But nothing could dim the beauty of so many of the people. Those exquisite girls with their little backward curving hands, and the wonderful colours all around us in people and buildings and the country itself.

It is some years since we were there, but I do hope, amid the seething traffic, there are still lorries painted like dragons, or ones made of teak trimmed with chromium lace, their windscreens outlined in fairy lights. I saw a tiger lorry and an eagle one, its giant wings, every feather painted, sweeping right back to the tail-gate.

Even the hotel where we were staying, at that point newly built in the royal gardens, had a fantastic quality, with every detail describing Thailand, from the door hinges to the 5-foot-tall bedside lamps, huge black vases covered with a pattern of formal gold leaves. A turquoise Buddha in a gold waistcoat sat on the dressing table where there was more than enough room for him, and all the towels and bathrobes were the saffron yellow of the robes worn by the priests we had seen on the streets outside.

We were on a business trip, en route for a conference in Sydney, so we had been booked into excellent hotels all round the world. This is normal for a whole swathe of business people, constantly circling the globe, but it was new to us and we were determined to make the most of it.

Many of our fellow travellers found the steamy climate of Bangkok very trying. It was certainly extremely hot. And humid, and at one point there was a storm of rain which came down in sheets, not lines, causing instant flooding in the streets. Tony and I were lucky in that he is impervious to heat, as he is to cold, having a remarkably efficient personal thermostat, and I positively like it, even humid heat.

Of course we were also fortunate, in Bangkok, in being in a hotel with excellent air-conditioning so, had we wanted to, we could escape the heat outside. This too was wrong for one delegate who said crossly, 'It is ridiculous to keep it as cold as this. I had to

send for a blanket last night. I never slept a wink. Of course it's not healthy, all this recycled air. I am sure it doesn't do my blood pressure any good.'

As soon as we could, on our first morning, we were out and exploring. First the Thieves Market and then lots of other little markets, and they were not as squalid as we expected although the canals – still open at that time – were more so. The people looked, on the whole, clean and reasonably well fed, but what was remarkable was that most of them looked so happy. Not just smiling, but laughing. The one who had set this pattern that we kept meeting throughout our stay had been the courier on the bus from the airport the night before. 'I am Sue Chi,' he said, falling about chuckling at the very idea, before giving us useful information about money and so forth. Such as the fact that one baht was worth so-and-so, and 'nobody calls it a tikel but just the same, a tikel is a baht'. Sue Chi could hardly impart this for laughter, in which inevitably we all joined, even after a very long and trying flight.

We watched the buying and selling in the markets, and people gossiping in the street, and they all found so much to giggle about, as had the porters taking our luggage to our room the night before, and the waiter who brought our breakfast. It was a great introduction to the place, all this hilarity, though we were, of course, perfectly aware that it was as troubled as anywhere else at heart.

Assiduously, we visited Buddhas in various temples, the 700-year-old one in Wat Po who was made of solid gold and was really quite something, and another gold one in another temple who was 170 feet tall, although all the gold on him was coming off because he was covered in little gold squares like toffee paper, which were fast peeling off. Tony felt he had to put a few bahts in the collecting box to help get the poor chap repaired.

In one temple we fell in with a tour party because the guide sounded so interesting (and was, so much so that Tony bought a book on Buddhism at the next bookshop we came to) and kept

shooting off into extraordinary digressions. 'Education is compulsory here for seven years and that is why 50 per cent of the children go to school,' he said, at which point he collapsed in mirth, and then recovered to prod a well-fed American in his ample stomach. 'Now you, sir, you are well past forty, and are you thinking of the after-life? Are you preparing for Paradise? No, I expect you will say you will do it later, but later is too late. If you pay the full first-class air-fare from London to New York you expect to get there, don't you? But if you only pay half-fare you might, I suppose, get half-way, and what good is that? Think what is below you, half-way across.'

We were glad we saved the royal palace to last because it made the temples look like beaten-up old wrecks.

On this trip, which involved so many changes of climate and so many different occasions, and little time to ourselves, I couldn't fit in paints. I had brought Aquarelle pencils and a small sketch-book, and looking at the pages now, I can remember what we saw but most clearly I can see my frustration. The illustrations do recall for me (if for nobody else) the pavilions of blue and gold, and china flowers, the mirror mosaic looking like sequins, the flying roofs, roof upon roof, of glittering green tiles with orange borders. And everywhere, gold sequin dragons outlining eaves, scarlet and blue and green with gold relief, wall paintings, flowered pillars, temples, minarets, pagodas and flights of marble steps.

In the middle of it all was the palace, built by an English architect in the Italian style, pink and white and gold, with great grape-blue doors decorated with gold dragons.

We wandered all around the palace grounds, in and out of temples, the throne room (familiar from the film *Anna and the King of Siam*) with its throne and cushioned platform under a series of gold lamé umbrellas, and out again into the melting sun.

Scattered everywhere in the grounds, confounding and contradicting the delicate intricacy of colour and design, were hideous stone statues, often more than twice life size, which had been brought from China as ballast in the junks which returned

home laden with Siamese rice. Ugly, heavy and out of scale. It was almost a relief to see that the exquisitely tuned Siamese eye could fail on occasion, or perhaps the statues were there for the same reason as a deliberate fault woven into a beautiful oriental carpet, because only Allah can make anything perfect.

As one of my favourite authors in adolescence had been Somerset Maugham, I was enchanted to find we were booked in at Raffles Hotel in Singapore. And, moreover, Raffles was just due for a major refit, but seemed barely changed from the vivid background of all those books. Air-conditioning (albeit a bit elderly and noisy) instead of the punkahs of Maugham's day, but otherwise, to one familiar with his Far Eastern stories, it was like coming home.

We had an enormous room and a huge sitting room and a cavernous bathroom, and a washing and drying room. In the sitting room were long cane chairs, a lavish bar and a writing table on which lay a supply of writing paper headed 'A.G.C. Trollope, Raffles Hotel, Singapore'. All we needed now were solar topis.

'It is intolerable, putting us in an old-fashioned place like this,' said a hard-to-please member of our party, and his wife added, 'The air-conditioning is so noisy. I shall never sleep. Anyway it is all so *big*. I feel as if someone may be lurking in our lounge.'

One of the pleasures of Singapore was the botanical gardens, not because of the orchids which we had intended to see but the rhesus monkeys who lived in the trees lining the drive. Tony explored the orchids but I went no further than the monkeys, fascinated in watching them. Even small babies were so efficient, travelling under their mothers' tums, with arms round their waists, and tails curled round their tails. Even one only two hours old, and more black than the greyish-fawn he would quickly become, could do it. I watched mothers haul in straying children by the tail, and teach them gradual independence. They are only carried by their mothers for twelve days, and it was pathetic to see one or two who had reached the thirteenth day having to learn to progress by themselves. One old monkey asked a tourist for a nut

from the long paper poke the man had brought at the gate. The man gave him one and pocketed the poke with only an inch sticking out. The monkey waited placidly till the man was busy talking, then leaped up and picked his pocket as neatly as the Artful Dodger, and made off, clutching the long poke of nuts to his hairy chest. I expect he practised that trick frequently, and hope he was generous to his relations when he climbed back up into his tree.

Unlike other places on our route, we had no letter of introduction in Singapore as we were there for such a short time, but glancing at the local paper, we found that a friend of ours was now the High Commissioner there (which we had completely forgotten). So we rang him on our last evening, and his wife Betty, welcoming as ever, said Arthur was busy but to come on over for drinks, and she would send a car for us.

Poor Arthur was busy with a trade delegation, which Betty thought she had escaped, but we found her entertaining a couple of left-over wives in the long, cool, drawing room. Devoted servants, who had faithfully served a long series of High Commissioners, brought us little glass pails of gin, treading softly across the polished golden acres of floor, each little pail wearing a towelling vest because of the condensation.

The trade delegation wives were heavy going; they seemed stunned by the climate and imposed a limit on the variety of questions we could ask our hostess, but it was an enjoyable hour, as was sailing through the streets in that splendid stately beflagged car, lined with white linen and bearing so much royal portent.

The previous day a nice Singaporean had offered to take us to see the Causeway, looking across at Jahore, and the War Cemetery where the glass, he said inexplicably, was 'soft like velvet'. I puzzled over this for ages, until I realized he meant grass, and that the grass was just that and not elephant grass. It was kind of him and we went, but with some reluctance since the whole of Singapore and the Causeway in particular is redolent of too much suffering for our generation. Once there, however, my mind was

diverted, as we walked over the Causeway, by an overwhelming storm coming up on our right. Jahore was only half a mile away. The sky was dark, purple-blue, and the sea flat and opaque like pewter, and the strip of land with the naval base on it – white buildings and black oil tanks – was a light clear frail green, the trees pale lace against the dark sky, while the foreground trees were brilliant emerald, flat and two-dimensional. I have never before or since seen tones so completely turned upside down. It was dramatic and exciting and in the long years since then I have tried, and failed, to paint it a dozen times. But I am glad we saw it, even if that magic moment remains only in my head.

We made it back to the car just before the rain came, and Lim drove the 17 difficult miles back to the city very well. We went through brown water swirling round our mudguards, and flowing down roads as though they were rivers. Other cars were stuck, and Lim drove round them and ploughed on. The floods just fell out of the sky and visibility was almost nil. We sweltered in the car as we couldn't open the windows at all and it had, of course, no air-conditioning.

We drove right through the storm, and by the time we reached the Raffles entrance the sky had cleared, ready for a starry night. Into which we ventured later to see what the streets were like at night. Very much alive, for a start. In the Chinese food market, in street after street, tables were spread in the road and Chinese people were eating exquisite little meals cooked on barrows beside them. However ragged the vest of a diner, his dinner was served in lots of bowls, and everything looked clean – tables, food, diners and cooks.

A number of people were asleep on the pavement. An exceedingly handsome old Indian in a pink turban slept peacefully on a cane bed under a grey blanket. We could see into some of the upper rooms of buildings, and saw paper hanging off the ceiling and strings crossing and recrossing rooms to make a family wardrobe. It looked better in the street.

Fiji

When we arrived at Nandi Airport on our way home from Australia the customs man asked if we were bringing presents for anyone in Fiji, and when we said no, he said, 'Ah how *sad* that you have no friends in Fiji, but never mind, you will make some. It is easy. Enjoy your visit and return soon.'

Now *there* is a way for customs to behave.

Our hotel was about 17 miles away and there was a fleet of cars lined up to take us. Alas, the car we were shown into already contained a couple, strangers to us, whom we had seen at the airport and on the plane. English, middle-aged, affluent and complainants of the first water, they had summoned the flight attendants non-stop, sometimes to order but mostly to complain, so our hearts sank at the idea of travelling so many miles with them. She was well into her stride. 'Oh my God. Oh Neil. What are we waiting for *now?* Neil, get him going. I can't bear this. Oh the heat. I can't breathe. I shall die. This heat is too terrible,' as she threw herself about the car with much groaning and abortive flapping.

I was sitting beside her, trying to avoid touching her because I loathed the contact. If she had kept still it would have been easier. The sultry sky soon spilled forth its contents, splendid violent tropical rain almost washing away the yellow road. She screamed every time we splashed through a flood, obscuring the windscreen, and every time a stone flew up and hit the car, so she was screaming loudly about twice a minute, on average. At least she couldn't keep complaining about the heat because the car was air-conditioned, but she made it a long, long 17 miles.

We had driven through wonderful country, brilliant greens, sugar cane, palm trees, and blue hills in the background. Native

houses made of a form of basket-work with thatched roofs. Lots of horses, and children cantering up to school on ponies.

The population then was already 50 per cent Indian, the lithe Indian physique contrasting with the magnificent giant-sized Fijians.

We passed an old, old Indian man on the road, long white beard, yellow turban, hacking jacket and long skinny brown legs emerging from his dhoti; he was prudently clutching a large golfing umbrella which, by the time we came upon him, had done its job, the storm being over. A young Fijian passed him, a head taller, his massive brown legs striding under his wrap-around skirt, his enormous confident bare feet oblivious to the stones of the road. They looked as though they had come from different planets rather than just different races.

Our driver, amiable and friendly as all the inhabitants we met were, couldn't help but sneak a dismayed glance at our unhappy companion when at long last we reached our hotel. His eye, meeting mine, said, 'Is she batty?' and I tried to say, 'She is tired,' but the words stuck in my throat. I didn't want to encourage any idea that British women, however tired, would behave as she had done all the way. Even if one had just done so.

The hotel was delightful, and situated in an area of cleared jungle on the water's edge. Nothing else near. Because the native huts are all small and pointed, it had been built on similar lines, a series of small pointed-roofed huts joined here and there by covered ways. Not, of course, enough covered ways for our arrival when the rain had resumed its deluge, and there was much splashing back and forth under huge umbrellas to get to the long low, hut where most of the bedrooms were. Our bedroom was upstairs and reached by a series of paths and ladders – and there was also an outside balcony running the whole length of the building. There was not a nail in the whole place. Every joist and beam, and all the furniture – made largely of hefty poles and slabs of wood which matched the human Fijian scale – was tied at every junction. It was fascinating.

From our window we looked straight out on to the beach and the sea, a view only interrupted by a tree which grew up as far as our roof and sheltered a mynah bird – or perhaps a family of mynah birds, because from that tree emanated, non-stop, the voices and songs of every bird we had ever heard, and many we hadn't.

In our spacious room we could gaze up into the dusky wooden steeple of our roof as we lay in bed. Behind one brown wall was an excellent bathroom, and suspended on the wall behind our bed were a couple of huge spears. Comfortable chairs were upholstered in yellow, and there was a thick yellow, green and coral rug on the floor, and giant straw lampshades on our many lights. We were very content. All the same we could hardly wait for the following day. Nothing official was planned. Outside there were at least a couple of miles of sand, a warm sea to swim in and all this exciting country to investigate: it was an enticing prospect.

When we found our way back to the main building for dinner we joined a number of our fellow delegates on the same quest. 'And what,' said one unappreciative person in a loud flat voice, 'are we supposed to do in a place like this for four days?'

Next morning we woke to blazing sunshine and the mynah bird pretending to be a parrot. A parrot talking Fijian, but alternating with 'That's it, then!', so we lay for some time idly wondering where he had learned his language and why this was his only English phrase, as we gazed up at the alarming spears suspended above our heads.

The sea, the beach and the lavish countryside were every bit as rewarding as we had anticipated, and late at night, after dinner, we couldn't resist a last swim in the warm moonlit sea. We were warned to avoid the sharp coral and to summon the hotel nurse at once if we scratched ourselves on it as wounds could quickly became septic.

We were very cautious crossing the coral sand as we got into the water, and then swam about in the shining sea looking back at the orange lights of the hotel freely and peacefully. I did, however,

scratch myself, a very small cut indeed on my ankle, but couldn't believe it was worth summoning the nurse to tend it. Half an hour later, though, I had to, and a huge laughing brown nurse soon appeared carrying a vast tray bearing enough kidney bowls and instruments for a major operation. Being Fijian, and wearing a flower tucked in her hair – as all the waiters wore one behind the ear – she had been unable to resist floating flowers in the bowls of sterile water.

All she did, as far as I could see, was clean the scratch with antiseptic, paint it with iodine and apply Elastoplast. 'Coral very bad,' she said, detaching her huge smile for a moment. 'You leave this today, very bad tomorrow – look how swelled it is now.' Her treatment, however, took a good fifteen minutes as she held each swab in tongs clutched in her massive brown fingers, and as she talked and explained with high cascading laughter, her large brown toes wiggled in glee. She was a joy to meet, and her treatment worked excellently.

Next day I was walking along a passage behind one of the maids when she dropped her duster. Neither pausing nor stooping, she grasped it in her toes, flipped it up behind her and caught it in her hand, all in one movement. It made me ashamed of how little use we make of our nimble toes.

During an afternoon siesta period, Tony and I walked along the beach, swimming as we went, and when we had gone quite a long way in the sunny silent afternoon, with even the birds in the trees along the backs of the beaches apparently having a rest, he too fell asleep in the angular pointed shade of a palm tree. I walked and swam on to see what was around the next little headland. It was a miniature beach. A tiny Trincomalee – a complete small circle of tranquil blue water with a narrow outlet to the sea beyond, and there I swam and paused on the beach before turning back, sitting under a tree, dreamily trying to imprint it on my memory. A shadow came between me and the sun. Two enormous brown feet faced my idle sand-digging toes. I looked up – and up, and up – and saw a vast smiling man wearing only ragged shorts and some

flowers on his shining brown torso, offering me a splendid piece of coral. This clearly couldn't be a commercial transaction – where would either of us keep or put any money, I in my bikini and he in his pocketless shorts?

I accepted it with thanks, and he said I was welcome and that he would see me later. 'Will you?' I squeaked, much puzzled.

'Yes lady, of course,' he laughed, 'I am your head waiter at the hotel.'

After that, I swam and walked back – walking barefoot on sand is surely one of life's greatest pleasures – collecting the drowsy Tony from under his palm tree on the way, and a band of children emerged from the trees and joined us. They were on their way home from school, and with them was their dog Kog – 'he belongs to all of us,' they told us. They were such friendly courteous children, with excellent formal English, and I remembered with some dismay that the airport was due to be enlarged to accommodate jumbo jets, so it was likely that many more tourists would soon flood this delightful and remote area, and change the attitude of its inhabitants . . . We were lucky to be there at that time.

There were, of course, activities to be enjoyed if one wanted them, such as expeditions in glass-bottomed boats to look at the sea bed, or a display of fire-walking by the islanders from Benga, which happens seldom because the men of Benga are the only ones who can do it and when they are brought over for a display all the other islanders have to come too.

The complainer, who was still in the hotel with her complaining husband, didn't want to have anything to do with either activity, but only wanted to play bridge. As there were clearly at least a few other people who would have been able to play bridge, the mystery factor which prevented them from declaring themselves never struck her. 'Why can't someone make up a four?' she reiterated. 'It isn't much to ask. What else is there to do in a place like this?'

The glass-bottomed boat would have been a delight – gliding over the curious landscapes and gardens which would suddenly

sheer off into intensely blue depths, and
swimming in and out all the time the
fish, royal blue, grass green, green
with red backs and yellow tails,
striped round about, striped up and
down, turquoise, black and green,
silver shaded to peacock blue, all
swimming over coral with blue tips
like gentians, and pale blue seaweed,
and red, and terrible things spotted
or checked in yellow or brown – if I
hadn't so longed to have the children
with me. Our friend Marie Williams
was with us that day and I found she
was thinking exactly the same thing. We
agreed that it made us feel so mean to be seeing and doing much of
what we saw and did on that trip, and having this feeling so often,
that it was hardly worth having children at all.

About thirty men participated in the fire-walking. Taking part
involved strict preparations, such as restrictions on diet and
women, as well as other prohibitions. The men sounded like a
storm as they approached because they all wore palm-leaf skirts
which made so much rustle. They were tall and magnificent, and
their palm leaves, dyed pink and green and yellow, swung round
their massive calves. They wore garlands and wreaths of flowers,
and came through the trees on this vast wave of sound to the fire,
which was a heap of rocks surrounded by flaming logs that had
been lit six hours previously. They pulled the logs away with staves
or their bare hands, and tossed them, still alight, into the lush
green bush, treading on the flaming shards and sparks without a
blink.

When all the logs were shifted, they set about the red-hot rocks,
making a flat surface rather than a conical one, and then hand in
hand and two by two, they strolled across it, only stumbling where
they would have stumbled on normal rocks. When they had all

accomplished this they threw green leaves on to the smouldering rocks and made a smoky bonfire, and then killed that fire with earth which they threw on top and stamped down with their feet. More earth and more men, till all the men were stamping in the fiery pit until it was extinguished, and then it was over, and the huge splendid men rustled away to their boats, and back home to their island (and doubtless to hot showers and transistor radios).

When we came to leave Fiji I couldn't decide what to pack and what to leave out, because we were going to Los Angeles via Honolulu, and our main luggage would vanish in between. I found I couldn't credit a past. Or a future. The only thing I was aware of was the moment I was in. I wrote my last notes 'sitting on our little square verandah with nothing round me but coconut palms and beyond them the sea, and no sound but the mynah birds singing every known bird-song'. I was so intensely aware of the beautiful place, and all we had tasted of it, that I couldn't visualize anywhere else, or bring my mind to bear on familiar matters.

It isn't surprising that one doesn't meet many expatriate Fijians. How could they bear to be away from home?

Rio

Overseas conferences vary considerably according to how efficient the host country is. We never went to enough of them to become blasé about them, but we were certainly lucky to start with one in Sydney, where – since it was the first concerning our particular aspect of the financial world that Australia had organized – they were on their mettle, and it was excellently done. All our hosts were welcoming and open-hearted (starting off with *all* the colleagues in Perth turning out to meet our plane at three in the morning and escorting us to our hotel), and all the functions, travel plans, seminars and hotels worked as they were supposed to wherever we went. We were scheduled for Perth, Melbourne and Sydney, each place laying on official occasions and a chance to meet people, visit offices and hear about local problems, and so on.

Wives, of course, had more time to themselves, and in the 1970s wives were rather docile about it, willing to attend whatever was laid on to amuse them, wherever it was. I don't imagine that obtains now, and even then, always having my eye on the local art galleries, I often ducked out of a bus ride to somewhere or other, or a fashion show, or a ladies' lunch. I was thus able to have a blissful time in San Francisco, my first experience of how beautifully the Americans look after their galleries (and what a joy they are) while Tony, nose to the grindstone, was being driven mad by the appalling mismanagement of all the formal arrangements. He wanted most of all to meet and talk with his San Franciscan counterparts, and the whole conference seemed to be designed to prevent rather than facilitate this. In the end he simply consulted the telephone directory, struck lucky, and was welcomed into several interesting and useful societies – two of which had sent

delegates to the conference who were feeling equally frustrated by the way all the countries seemed to be kept apart, rather than allowed to confer.

Possibly the prize for most chaotic organization went to Rio. Our hotel, on the far side of Rio, was a new – in fact, still being hammered together – skyscraper column, which looked very dramatic rising sharply out of the ground against a background of mountains which themselves seemed to rise straight up with no softening edge of foothills or undulations. One side of our large room, on the seventeenth floor, was a curved glass wall looking out on to the mountains crowned with the vast statue of Christ the Redeemer, gleaming against the starry sky.

The first day's session started forty minutes late because the microphones weren't functioning, so much of a beautiful morning was wasted. I had to go to the conference opening, but hoped there might be some time at the end of the day when we could escape, and go and see what Rio was like.

By the time we did manage this, the sun had vanished and a sharp chill wind was blowing a lot of filth about the streets, which caused me to remark that it was just like the wrong end of Glasgow. (Not now, of course, I hasten to add. Clean, nowadays, Glasgow is a far cry from the Glasgow of my childhood.) Grey skies and the bitter wind soon drove us back to the hotel, but we were later to enjoy the streets of Rio and its rainbow population very much in the sunshine, though we had to wait several days. The next day I found I had been booked on a mountain tour, a visit to a market and a lunch with samba dancing display. As this had been done for me by a kind, if mistaken, compatriot I had to go – indeed, I think almost all the women went, in a series of half a dozen coaches, preceded through the town by screaming sirens on motorbike outriders, so that all the traffic was swept out of our way.

In Rio traffic can overtake on either side – all the cars bear scars to prove it – and the driving is in any case anarchic, so I expect the only way of being sure you get through is behind a siren. It is

exhausting, though, to travel in that noise, and that noise turned out to be the leitmotif of a long and dreadful day.

As all the German women had surged on to the bus and clawed their way to every window seat by whatever means they could, I sat on one of the aisle seats, perforce. The women either side of me, one next to the window and one across the aisle, talked across me non-stop. I offered to change places with either, but '*Nein,*' they replied firmly, they were quite comfortable. I could barely manage to peer round the woman at the window on my left to see where we were going, because she was leaning forward all the time talking to her friend. Then we were let out briefly to take photographs, before being herded back into the buses by two courier girls in yellow trouser suits. 'Everyone back to their seats!' they yelled.

Absolutely not. I nipped quickly on to another bus just as it was starting; I didn't care if I had to stand. But there was a place, and a congenial place, beside a Jamaican woman, with whom I spent the rest of the day, listening to accounts of life there and attitudes and politics and so on.

The bus chugged and lurched and wound its way up a mountain and down the other side, and I was amazed to see busy lizzies as big as bushes growing by the roadside. At about 2 o'clock we stopped and were decanted into a large shed containing stalls stacked with the most horrendous tourist trophies. This was the 'market'. My Jamaican friend and I saw a flight of steps and struggled out into God's extremely good fresh air. We were desperate for a glass of water – the bus had been very hot and we'd been in it for three hours. One of the couriers told us there were drinks on the terrace, but all our searches only found the odd waiter shambling about with trays of empty glasses. We finally found a loo, and as we queued and queued, we caught sight of the samba dancers, sitting on benches waiting their turn, their vast magenta skirts spread around them like flowers, their resigned black faces ranging from bovine stupidity to little wrinkled nuts. They all appeared well past middle age.

Eventually, we found our way back to the others to find lunch, a buffet, was now going on – indeed, some were already going back for second helpings, which I thought showed admirable enthusiasm after such a morning. I couldn't be bothered with it, but my friend fought her way through and came back with a laden plate of chilli con carne, and rice, and various vegetables and patties and this and that, and a white substance which she didn't recognize but thought she would try. Would I like to taste it? Now she had it she didn't feel brave enough.

I tasted it. It was semolina pudding.

We sat for hours among the remains of all this food, waiting for the samba show to start. Clearly it was overdue, because other people surged in to eat. The bus drivers, the siren-screaming police outriders, guns bulging at their hips, the kitchen staff, lots of aunties of everyone else and a few children.

At last a young man leaped on to the platform, nearly hitting his head on the low ceiling as he was rather tall, and told us at great length that we were about to hear a world-famous samba singer. Along came a girl in pink trousers and steel spectacles who, with appropriate hand clapping, YELLED into the microphone.

Soon my assaulted ears felt as if they were jumping about agitatedly on their own. The noise had been unremitting all day, in the bus and then the female voices all shouting at each other in this low-ceilinged place, and now this clamour.

Six men with drums joined her, proceeding to show us step by step how a samba is done. We were all supposed to clap the rhythm. One minute would have done, but she belted it out for at least ten, and then the drums kept going for the old ladies in the magenta skirts and green lamé turbans to demonstrate the dance.

The one nearest us did keep time as she tottered about but had no teeth through age and decay, so looked abstracted. The next one must have been deaf because she didn't remotely keep time, just wobbled about in her grotesque clothes holding an evening pochette under one arm. Then there were three large women in *huge* sequinned crinolines and fantastic head-dresses, who just

stood; it wasn't at all clear what they were there for, but clearly one only qualified for those head-dresses and crinolines if one was well over fifty and had at least a 36-inch waist. One of them, bridling back into her double chins, coyly tossed a (plastic-wrapped) rose at the nearest elderly American husband – a few rash husbands having deserted their duty in order to come with us – but even he failed to respond. Perhaps he had read the inscription on his wife's rose, which said it came with love from a jewellery firm. The only fleeting glimpse of dancing we had was as we were departing. A young black girl in a pink frilly dress bounced on to the stage and samba-ed beautifully, soon joined by a snake-hipped youth who was just as good – so, finally we saw how it *should* be done.

Wilted by thirst and, now that I thought of it, hunger, I positively ran to a bus, longing to get away.

Fortunately for us, Tony and I had a closer look at one household in Rio, and had at least a small taste of the original and unique flavour of the place. A friend of a friend had given us a phone number. 'Fernando will welcome you,' we were told. 'He's good fun. You'll like him.' He did, and we did, although when we arrived at his flat after he invited us to come and have a swim on Copacabana Beach from his club, we found to our dismay that his mother had just had a heart attack and they were waiting for the ambulance. Making all possible sympathetic and appalled noises, we turned to flee. 'No, no, nonsense,' said Fernando. 'She is all right. She'll be gone soon. Gina will go with her. I'm taking my boys to the beach anyway. You must stay – they're looking forward to it and so am I. Come on in and have a drink till the ambulance comes.'

With trepidation, we did. We waited in a long narrow room lined with books on accountancy and law, and wished we were anywhere but there. Light filtered through the pale linen curtains with café-au-lait shadows in their folds, and gleamed on the heavy dark furniture, and we tried to think how we could decently leave this delicate situation.

The ambulance came in about five minutes. 'Are they always as quick as that?' I asked Fernando.

'Of course not,' he said, 'but of course for us. For some they don't come at all.'

When Mrs Henriques had been removed, protesting, to hospital with the doctor and Gina (whoever she was) in attendance, we went down to the beach with Maria, Fernando's pretty wife, and their children, leaving Fernando to ring his father, who lived the other side of the city, to break the news of his mother's illness.

His father must have been in the true Brazilian tradition. The previous year he had smashed his leg in a car accident and was taken to hospital where they were going to operate on him. He asked for a glass of whisky and they said, sorry, not before the operation. So he asked the nurse to pass him his briefcase instead, and from it he took a machine-gun, saying, 'Now get me my whisky.' Somewhat naturally they did and when he had drunk most of the bottle, he said, 'Now operate. Do whatever you like.'

Fernando also told us about his young brother, a worry to his mother because he lived a life that could only be described as alternative. He had just rung to ask Fernando for his legal help because he was going to be shot. 'Normally,' said Fernando, 'I'd have just said "serve you right". But as it was my brother I had to do what I could so I put it right for him.'

'How?' I asked.

'Oh, I just rang the minister and said, "You shoot my brother and I shoot you." We'll have no more trouble – anyway, not till the next time my brother misbehaves himself,' and he laughed heartily at the idea of it.

These stories didn't seem at all peculiar at the time, given the fact that it was so peculiar for me to be listening to them while reclining on Copacabana Beach, which was exactly as one had always imagined it and seen it in films. We had reached the beach via Fernando's luxurious club, where, crossing the elephant grass between club and beach, I had met an arara bird, which I had previously only seen illustrated in books. A big scarlet parrot with

turquoise and yellow wings and a long blue-and-white tail, he was very beautiful. He was walking about picking up things with his claws and putting them in his mouth to see if they were nice to eat. Mostly they weren't.

After regarding me earnestly for some time, peering up to see if I was likely to behave (not all humans did; a little boy – whom the arara clearly recognized – kept pursuing him with a can of water to tip on his indignant scarlet head), he walked purposefully towards me and stretched out a tentative claw towards my painted toe nail.

'Don't you dare eat that!' I said.

'Not?' he asked, peering up again. He thought it over. He prodded my toe with his beak. Very bravely I stood still to see what he would do. He shoved my big toe to see if it would come away from the side, then looked up at me again, to see if I would stand for him taking a bite. I let him get quite near, beak open, before I jumped away. I was careful not to laugh at someone so dignified, if – compared with me – small, but I was not going to let him try the rest of his experiment. He kept on walking after me, his eyes on my toes, deep in thought, sure that there must be an answer if only he could think of it, until I vanished through the gate to the beach.

Beside us on the beach a group of ten-year-old boys were playing. All the time we were there – about three hours – they played and all their games were shooting games. One of them, at one point played alone, and he made a life-size sand man lying on the beach, and then he made bullet holes all over him. He acted each shot very dramatically, himself both killer and killed, and was only *just* able to drag himself up to the sand man in order to poke another hole in him, time and again.

Further along, middle-aged and elderly men did some conscientious keep-fit exercises. Young things played with deck quoits, and two armed policemen stood nearby observing to ensure that nobody misbehaved.

A woman with a shopping bag and a neat little daughter came along the edge of the sea with a bunch of gladioli which, after

looking at her watch, she put carefully in the water in a pattern, rearranging the flowers several times to get it right. I asked Maria what it was about, and she told me it was voodoo – the woman was trying to placate the goddess of the sea. I did hope it worked for her.

Some very good-looking young people wandered past us, proving that this cocktail of races can have some extremely decorative results. An extremely beautiful young couple came along, tall, tanned, expensive-looking, and were greeted warmly by Fernando and Maria. The young man explained that they felt like swimming out to the raft, and could they leave their things in the care of our little encampment? The girl slid out of her ethereal shift, disclosing an even more ethereal bikini, and pinned her shining copper hair up on the top of her head. She flung her beach bag down on the sand beside us, a bit carelessly, and its contents all tipped out – a copy of *Vogue*, a bottle of sun lotion, a sandal, a gold-backed comb and a small sleek shining gun.

Laughing as she scooped up this cascade and put it back, Maria wished them well with their long swim and promised we wouldn't be leaving the beach for another hour.

Copacabana Beach was fascinating in itself, never mind our congenial company, which the gun-happy Henriques family certainly turned out to be. There had been plenty of room, even on a Saturday. The sea was not the best, or cleanest, that we had ever seen, but it was there, and warm, and it was a lovely day. We swam happily, looking back at the long pale fringe of apartment blocks sweeping round against the dramatic mountain background. Rio was proving to be as dramatic and intriguing as we had hoped it might be.

Getting Away

It is always such a problem getting away at all, and it is no help that I am well aware that, in our case, we have ourselves constructed all the anchors that bind us in place. I am not counting the years when growing children brought their own constraints – all of these were sought and welcomed, and we were properly grateful for them – but later, one is supposed to be able to exercise a certain amount of freedom, even prior to retirement. There we have scored a quite remarkable failure, and it is entirely our own fault.

Tony managed to retire from his City job, sure enough, but for some years this was hardly noticeable, as he continued to go to London, only to do ten different things instead of one. I had never contemplated retirement, since few women manage to retire from their domestic chores, and how does a painter retire when there is still so much to learn? In any case, we live in a village, and are fortunate to do so, but it does bring its commitments as well as its rewards.

So getting away takes a bit of planning, to put it mildly, what with my teaching and painting and our various local duties, but the real complication is our animal household. All our feline and canine dependants. Nobody has ever forced us to have any of them, with one exception which we don't regret.

Once, some years ago, we had ourselves organized to go away for the weekend. We were all packed, dogs and bags already in the car, a kind friend alerted to come and feed the cats, when the front doorbell rang.

There stood a neighbour carrying a shopping basket and wearing a wide smile. She said, 'I've just been down to visit my daughter in Bristol. She's got three lovely kittens and I know you

111

like cats so I've brought you two of them,' and she handed me, out of her basket, two ginger kittens the size of apples.

All we could do was thank her profusely, and, when she had gone, look at each other in dismay. We had three cats already, but we could hardly leave these tiny strangers in the care of our cats and the daily visit from our helpful friend. What about our wonderful weekend plans?

It didn't take us long to solve this dilemma. We shifted our bags into the back of the car from the boot, and turned the boot into a nursery. We put in cushions, a litter tray and a water bowl, and went out and bought some kitten food and milk, and Romulus and Remus spent their first few days as members of our family in the boot of the car. It clearly had no ill effect on them, and they grew into vast amiable sociable giants, so bore no resentment at their early treatment and, like all the animals we have ever had, fitted in without any trouble.

The only snag about having twin kittens was that we could never tell which had done the wicked deed, or which was running up the drawing-room curtains, and other people could never tell them apart, though very soon we could, both by looks and character. The nicer one, Romulus, is still with us at sixteen and a half and extremely well, though he doesn't tax himself much. He is huge and gentle and loving and timid. Not long ago he applied to me for help because, he indicated, he couldn't go out of the back door. Since it was open I couldn't imagine what his problem was, and was amazed to discover that it was a very small dandelion, which had grown in a crevice since the previous day, and which he found too frightening to pass. Once I had removed it he was able, with great relief, to go once more outside.

When one of our household comes to the end of his or her life we are full of resolve to cut down, perhaps to one dog and one cat, but somehow it never happens. Partly because the relationships between them all are such fun and so fascinating to watch – none more so than the present one between the dachshund puppy, James, and Henny-Penny – and partly because it is a pleasure to be

Romulus, Henny and Remus, one summer afternoon.

able to give them all a happy life, and to have such a variety of characters about the house.

Henny-Penny flew in one day about seven years ago, a smart Black Leghorn pullet. She tried several of the gardens near us – we live in the middle of the village so she had plenty of choice at hand, or at claw. After a few days she settled on our garden and there she has lived ever since, pecking about during the day, so that the flower beds are permanently under a rash of wire-netting patches to stop her digging up seeds and seedlings as soon as they are sown or brave enough to break the surface of the earth, and at night sleeping in the branches of a tree, usually the big old yew or the magnolia. Sometimes in the winter she chooses a branch which is quite bare and exposed and I can't bear to see her, clinging for dear life to the storm-tossed branch, her feathers all blown backwards over her head.

113

We made her a coop but she ignored it and there is a barn with open doors and rafters where she could shelter but she won't. This didn't surprise me, my previous experience of hens leading me to think they must have brains no bigger than a pea, but I have had to retract that view since Henny-Penny came into our lives. She is no fool. She learned very quickly when the row of feeding bowls for cats and dogs appeared, and with a most exact, if invisible, watch on her scaly leg, was always in the kitchen at 5 o'clock if I wasn't quick enough to shut the door first.

She also learned that one visitor, our friend Norman, usually came in a blue car on Saturday mornings, and that there would then be bits of digestive biscuits for all applicants. When we bought a blue car much the same as his she was at first confused, rushing to greet us at any time of the week or the day, and falling back with disgust when she found it was only biscuit-less us. Then she learned the difference between our Vauxhall and his, and only came to greet us if she needed more corn on the special little shelf made for her by the kitchen door. Having clearly decided in youth that she was not, after all, a flock bird and so struck out on her own, I think she is not at all sure what she is, and is deeply unworried about it.

Having asked around everywhere I could think of when Henny-Penny first arrived, and failed to find her owner, I only heard, sixth-hand, about three years later that she must have come from a farm about a mile away, where various pedigree birds are kept. But by then nobody could have persuaded her to go home, or if they did I am sure she would come back to her chosen place. We never clipped her wings so she can do just as she pleases. And she does.

Henny-Penny likes to come into the house for a chat and does so freely in the summer when all the doors are open, and all year round, every time I walk in the garden she murmurs from wherever she is, and comes to join me as I pick flowers or do a bit of weeding or pruning.

Of course, being a hen, she goes broody in the early summer and that is very trying. Not only do we lose our steady supply of small but very wonderful free-range eggs, whose concrete-hard

shell is almost filled with the glowing orange yolk, but, left to herself, she just sits and starves for the statutory number of days. Even if I take all the eggs away, even the china one I use in the hope that she'll lay in the same place twice and save me much exasperated hunting in the deep thick hedge, she sits obstinately on. The first time she was broody, I had forgotten such hen lore as I had and simply let her be to do whatever came naturally, and she emerged at the end of it almost skeletal and very irascible, and no wonder. She had come for food only every three days or so, ate and drank feverishly and rushed back to her empty nest to sit on her non-existent eggs. So now, whenever she becomes broody, I pick her off the nest every day to be fed – although it makes her very cross indeed with me, giving me a very hard time vocally, but she never pecks me (though she pecks other people eagerly if they try to touch her in this tetchy mood). In order to stop her rushing straight back to brood again, I carry her about with me while I dead-head roses, or whatever I can do with a cross hen under one arm, and it does take her mind off her fruitless occupation for a little while so that she explores the garden a little before going back to the nest.

Once, submitting to all her exhortations about all this broodiness being entirely natural, we were given four fertilized eggs for Henny-Penny to sit on. The farmer friend who supplied them said to let her hatch them out and he would come to collect the chicks at once, and by the end of the day she would have forgotten all about them.

Calculating the time, we found to our dismay that we would be away when the chicks were due to hatch. However, in our absence the menagerie and house are left in charge of friends, Joy and Ronnie, who move in. They know all about all livestock, and are undismayed by any bizarre event, so it was they who found the first little black chick scampering in the hedge. Andrew, the farming friend, came at once as promised, and he and Ronnie crawled about in the bramble-filled hedge trying to catch the chicks, all the time being attacked in a most positive and

determined way by Henny-Penny. In the end they realized that they couldn't separate mother and children, so Henny-Penny and her chicks were taken back to the farm where she was able to bring them up in a luxurious greenhouse with every comfort.

When she came home eventually she wandered about the garden saying, 'Tooooook? Tooooook?' in a questioning voice and I watched her, from the kitchen window, trying to get her bearings. I also watched her, at exactly five o'clock, suddenly think 'Dinner-time!' and come whizzing down the lawn, across the courtyard, and into the kitchen before I could shut her out, her aim always being to eat the cats' food, which she finds much more interesting than her poultry meal. I did give her her own dish at the end of the row, but that was no fun. She likes to steal from the cats and they stand back like gentlemen and let her.

She is, however, their friend, and when she makes hollows in the earth, to recline in, in the warm sun, as often as not a cat is lying there beside her. The dogs, too, are fond of her, and greet her with a cheerful lick when they meet, which she accepts as her due. James, the dachshund, arriving at three months, never having seen a cat, never mind a hen, was an unpleasant surprise to her. He chased her with glee. He didn't do it twice, at least not in my presence, but I did see him skid to a halt in mid-chase when his conscience kicked in, so I think there must have been a flurry or two before they found a *modus vivendi*.

She learned not to run, but to sit down like a feathered tea-cosy. There is no fun in playing with a feathered tea-cosy, as James realized at once. But they did evolve some games that she clearly enjoyed. Horrified, I saw, a little while ago, Henny-Penny's head right inside James's mouth and he was shaking it gently.

James plays non-stop in this fashion with Apollo, who is a two-year-old Burmilla cat, and they clearly have firm ground rules about no biting and no claws, but it *looks* most alarming. As did this game with Henny-Penny. I yelled at him, and he spat out her head, laughing at me. Henny-Penny just sat there. She wasn't stunned. She looked at him inquiringly. She wanted more and

when he scampered about, giggling and offering to do it all over again, she hopped towards him, inviting him to do just that.

It was the oddest game I ever saw, and I had to retreat and let them get on with it, reflecting that Henny-Penny, like Apollo, always had the upper hand because of being able to get on to a branch or a wall and so easily out of James's range.

The only advantage of her broody periods is that once or twice she has chosen a nest near the outside of the hedge, and therefore was a perfect and permanent sitter for me. I had great pleasure in painting her with the sun glittering on the little copper-gold feathers on her neck, and the pale-blue highlights on her glossy black wings. Painting portraits of people would be very much easier if they could ever be caught in the remote self-absorbed stillness of broodiness.

The dogs and cats are all good models, too, albeit only still when asleep. I still mourn, without reservation, the death of Artemis, a Burmilla I was given who was so beautiful that she would have been a joy to have around just for her looks, without the bonus of her affectionate and intelligent nature. She was shaded dark beige to cream (though her official colour description contained all sorts of other colours, including lilac, which I didn't understand at all until I tried painting her), with dark points and blue eyes defined by dark edges as though she had smudged her mascara. Her fur was soft as a cloud, and she never failed to answer whenever one spoke to her. 'Good morning, darling.'

'Prrrp.'

'Nice day, isn't it?'

'Prrrp? Prrp.'

She also came when she was called, always, and was the only cat I have ever met who would obey an order delivered across the room in an ordinary voice. Almost any cat will stop for 'Stop that! Don't scratch the sofa!' or realize one means it with 'Out! We've had enough of you,' but one could say to Artemis 'Don't do that' or 'Please get down from my desk' quietly and she'd do it.

I do hope some cat-minded angels are enjoying her now and have not forgotten the earthly delights of touch and vision. And I am glad, too, that I couldn't stop painting her so have many reminders of her beauty, even if my tactile senses still feel thoroughly deprived without the feel of her in my arms.

St Petersburg

At our Golden Wedding party Andrew made a very funny speech about the trials of having irresponsible parents, who were discovered to have flown off to Russia in a blizzard, for a few days, just when all the party preparations had reached the stage of decisions and lists and addresses.

The trip had been a surprise to us, too, being presented as a last-minute chance we couldn't miss, but the blizzard was a nasty surprise to many more.

As we read in awe about the temperature in St Petersburg being −12 °C, England was just as cold, but wet with it. Driving to Gatwick was alarming, first over deep new snow, and then over grey slush, with heavy snow driven slap on to the windscreen all the way. The papers were full of pictures of empty airports because nobody was flying. Firms like Marks & Spencer, Barclays Bank and ICI had even forbidden their personnel to fly unless it was absolutely essential.

So we were bewildered to find, once we had parked the car in one of those endless remote open car parks, the airport full of people. Who were they all? Where were they hoping to go? The answer to the former lay in the latter question. They were passengers hoping to go to Dubai, China and Dallas, but they had been accumulating there for days, longing to get away but being unable to.

The object of our journey was to attend the reopening after restoration at long last, of the theatre in the Hermitage. Hearing that this was to take place, and that, at the last minute, the authorities in St Petersburg were concerned that the audience would not match the glories of the exquisite restoration when shown on television, the excellent and much-missed Prince George

Galitzine had offered to bring a plane-load of Brits, who would all dress up nicely and look suitably sparkling against the gilded fronds and lavish drapes, and general elegance of the little theatre, and this offer was gratefully accepted. I can't remember at all how we became involved but I am glad we were.

People told us all sorts of things by way of advice. For instance, we *must* have fur hats and if possible coats. We felt that was absurd for four days. Tony had his ordinary felt hat and I had a giant scarlet wool scarf. He had a good thick overcoat and so had I, and we bought snow boots from an Army surplus store.

They said no baths or basins had plugs, so take a squash ball. We thought a universal plug might be more useful so took that and didn't need it. They said – and this was reinforced at Gatwick by all those in our party who had experience of travelling to Russia – to take food. Serious food. They had cheese and ham and salami and all sorts of things with them, and they were very sensible.

George advised us to bring mineral water because the Russian stuff was so horrible and expensive, and one had to have it, if only for brushing teeth. And he also advised vodka, far cheaper at Gatwick than in Russia. All I had brought as iron rations was a packet of chocolate biscuits. Ever since we have travelled childless we have enjoyed having nobody to consider but ourselves, so tend to live on the country, or go without, rather than have the bother of anxiety for the morrow. Obviously, in countries where one has to, we see that we have water with us, but otherwise tend to wait till we meet food again. We did, however, rather regret being so superior about it when we found ourselves dining, twice, on vodka and chocolate biscuits. We were only there for four days and, as we supposed, we had *something* to eat now and then. We both can, at a pinch, eat almost anything, even if we would rather not, but St Petersburg pushed us to the limits, and even Tony opted for hunger. That, however, was a minor matter within the over-whelming rest.

Our room, in a tall slab of a hotel, looked down from the seventh floor on to the *Aurora*, the battle cruiser moored on the wide sweep

Rosemary by the River Neva.

of the River Neva, from whose deck in 1917 a blank was fired as a signal to start the Revolution. On the distant bank, buildings and domes and pinnacles and towers looked purple against a riotous sunset, and the surface of the water, which was thick ice, sparkled in brilliant colours cast down by the sky. On another part of the river, the following day, we saw people walking their dogs on the ice, which looked odd as they walked around the idling boats. My many attempts to paint this river scene were doomed. It was too theatrical, I couldn't translate it into comprehensible terms.

The hotel had a hundred rooms on each floor, fifty in each of two wings, and in the centre a space where the lifts were, and a concrete staircase and the dragon lady who kept the keys, handing them out with an unrelieved scowl. I had been told to take soap for her, which she accepted with no change of expression.

I try not to think of things like fires, but do feel that perhaps one of us should know, so I walked down to the end of our corridor to see if there was any other escape except that central lift shaft and stairwell. There wasn't. Just a double row of rooms, twenty-five on one side, twenty-five on the other, and not even a cleaning cupboard to break the line. So I tried not to dwell on it. (It was just as well we were not there three weeks later when, on the floor below, a television in one of the rooms blew up and seven people were burned to a crisp.)

We were lucky in having a great deal of sunshine in our four days, which we were told was rare in February, so all the beautiful palaces, so exquisitely restored, gleamed yellow and white, pale green and white, and ochre and white, and the cathedral of St Nicholas was pale blue and white, with golden domes, set in a snowy birch grove.

En route to the cathedral in the coach, it made me laugh when I recalled our dreadful, blinded, cautiously slow progress to Gatwick in the snow. Here everyone drove with abandon on impacted snow with bald tyres, and the casualties in the shape of cars, wheels or car parts, were just lying about until the snow covered them up.

Never mind thermometers, the cold was quite something else. Warm from the bus, I left my coat there as I walked the few yards to an open door. I was wearing a tweed suit and a thick sweater, and in seconds was cold right to my bones. But, treated with sensible respect, we found the cold was kept well at bay with our good coats, Army boots, my big red scarf and Tony's hat.

Inside St Nicholas we recognized the pious chaos of the Orthodox Church, familiar to us in its Greek version. Old grannies bent double before their favourite icon, crossing themselves every thirty seconds, others shoving through with candles to sell, and there were sightseers wandering and gawping, and a small devout group attending to the Mass which was going on at considerable volume – a group of excellent singers being hidden away behind the screen – but all safely enclosed in the screened-off sanctuary.

The building shone and glittered with gold. The ceilings were low and vaulted and alive with shadows from the gold candelabra, and candlesticks and candles suspended from a golden frame. There were gold designs on the arches and many icons were 'dressed' in gold, that is, obscured except for the face (long-since blackened by time and candle smoke), which is the way rich people give a present to the Church and at the same time show how rich they are. The cathedral in Cuzco, when we went to Peru, was similar, only it was all silver and of more usual cathedral proportions. This one was so low because there was an overflow church on the first floor.

Stepping discreetly over the feet of some violently praying black-clad grannies, we came to a row of what looked like wax effigies lying under brocade blankets with candles and flowers about them. One had a prayer on a slip of paper on his forehead so I looked closer to see what language it was written in. Then I realized. These weren't effigies. They were bodies. The Mass, to which so few were paying attention, was a funeral mass, conducted for five people at once, in the economical way that rectors now do christenings if they can.

We were herded back into the bus just as the priest began to distribute the Sacrament to about a dozen people who stood near

the railings outside the sanctuary. One old lady, who had been alternately kissing an icon and polishing the glass ever since we entered, was only 3 feet from the priest, but ignored both him and the Mass, and we left her still kissing and polishing.

Next we went to the Russian Museum, which is housed in an exquisite palace built by George Galitzine's great-great-grandfather, and where his mother was born and brought up. There is a fabulous salon in the centre of the house dedicated to Rossi, its Italian architect. Like the rest of the house, it is perfectly restored – patterned parquet floors, magnificent white and gold ceilings, and grisaille frescoes and borders, and containing all the furniture he designed for it – wedgwood blue and gold, and side tables with tops made of what looked like heavy blue glass, and marvellous paintings for which we didn't have enough time. But I have printed on my mind, very clearly, a portrait of George's mother as a little girl with her mama, which enchanted me.

We had an excellent and well-informed guide, Ludmilla, and at lunch time she sat across the table from me talking to one of our fellow travellers whom she had met on a previous visit. Ludmilla was retelling a lovely story. An English couple, on a recent visit to Russia, had used her guiding services for a couple of hours and then given her a lift home afterwards. The husband asked how she would be celebrating New Year, and Ludmilla said, 'Not at all because what is New Year without champagne and there is no champagne obtainable for us.' The man said what bad luck and they both thanked her warmly and drove off. They were going home next day so she didn't see them again. On New Year's Eve, however, there was a knock at the door, and there stood a messenger with a bottle of champagne and a note of good wishes from the English couple. 'It was so beautiful a thing to do. Look, I am in tears now to remember it.' She had written a letter of thanks and was hoping one of us would post it for her when we returned home, British post being more reliable than Russian. 'Of course I will,' said her acquaintance. 'We'll be home on Tuesday, and if I miss the post that day they should have it on Thursday.'

'Better than that,' I said, leaning across the table. 'Tony and I will deliver it on Tuesday evening.'

I had recognized the names of friends who live only half a mile from us. We knew they had been in St Petersburg for Christmas, but had not, of course, heard of that delightful St Nicholas act. It was nice to hear of it from its far-away source.

We went to the Kirov ballet – a beautiful theatre, all glittering with bright gold and lavish pale-blue silk drapery, and every seat, every gallery, right up to the sparkling chandeliers, crowded with eager, enthusiastic people. Many of the audience were fans of an up-and-coming young dancer, the Prince, and one could easily see why.

Going home in the bus one of our number, a ballet expert, was very dismissive. She didn't like the scenery, didn't like most of the costumes, felt this dancer wrong for that dance, and that dancer wrong in the part, and so on. I've seen boring ballet in my time, but this was so exquisite – or at least to my less demanding view – that I could have watched it forever. We very nearly did and couldn't believe, emerging into the frightening cold of the night air, how many hours we had been there. I had thought the vast ostentatious elaborate scenery was exactly right, most of the costumes superb, and the dancing of a quality I had never seen before; and such a huge *corps de ballet* – about twenty in one group, twenty in another, ten here and a dozen there – was rich and exciting. The orchestra was enormous, too, and excellent, and even the safety curtains a work of art. An extravagant, splendid no-holds-barred evening which we both enjoyed to the full.

Reflecting afterwards on it, and whether much of the splendour was down to sheer size, I remembered a concert given by a famous Moscow orchestra that we had recently attended. There were hundreds of musicians – sixteen double basses, for a start – and much good it did them, as they plodded and crashed their way through the evening, all wearing expressions that reflected their playing. Soon the audience caught the virus and were wearing matching faces. So, it's not just size.

We saw the Catherine Palace and the Pablovsk Palace and the collections at the Hermitage, and walked through Nevsky Prospect, and a market (where one cheerful stallholder begged me to buy a Russian computer, holding out an abacus). It was all fitted in somehow to our brief stay. I was quite pleased when we failed to get into the Kazan Cathedral because there was filming going on, as I was in danger of getting ecclesiastical indigestion, having visited so many churches already. Tony was disappointed, however. Absorbed by its description in our splendid guidebook, Kazan Cathedral was the one he most wanted to see.

We had spotted this particular guidebook in a book shop on Nevsky Prospect but, as it cost the equivalent of £15 and we were near the end of our stay and our budget, we refrained. Later, walking back to the hotel, we saw a lad with a bookstall and there was the book, unpriced. Tony fished out his roubles, to count them and see if he had even half the book-shop price, and the young man pounced at once. 'That one,' he said, pointing to a pound coin. We later discovered it was then worth about ten pounds to him, so we both did well.

Nobody, among all our advisors, had told us to take a few pound coins; Tony just happened to have a few in his pocket, and so did I, and extremely useful they were. At one of our unspeakable hotel meals, the table almost covered with bottles of Pepsi Cola which neither of us can stand, Tony begged the waiter for some mineral water. No, there was none. Beer? Wine? No, nothing else at all. No, no fruit juice or lemonade. As he turned away Tony casually put a pound coin on the table. In a minute the waiter was back with not one, but two bottles of excellent wine, and a beaming smile.

All the hotel staff were selling caviare on the side (of which George had warned us, so we bought it only where he advised). I imagine the same caviare went round and round the system, because in the cattle-shed chaos of the airport on the way home, when our luggage was searched, it was not guns and drugs they removed, but most of the caviare everyone had bought, stating you

Tony wore gloves in St Petersburg, but scorned a scarf.

were only allowed to take home one jar, and over a hundred jars were retrieved from the plane-load of passengers by an overbearing customs woman. We were all packed so tightly into a pen that couldn't move, and one elderly lady became hysterical – which wasn't much fun as nobody could help her, but the excellent courier from our travel agency, spying where the customs woman had put the large plastic bag containing all our caviare, in the commotion pinched it neatly back. When at last we were released into the departure lounge, the courier went round returning jars to their rightful owners, like feeding the five-thousand. For those with less assiduous couriers, or none at all, it would seem that the jars went straight back to the hotel to be recycled.

One of our number had been coming to Russia every year for the past twenty years, and was used to the disorder and

127

incompetence and nonsense. The present atmosphere, however, seemed to him something different. World pressures having entered (though there was no way of keeping them out any longer), bewilderment and dismay was rife, and the Revolution now appeared to many Russians their only moment of glory.

The object of our visit, the grand gala opening of the Hermitage Theatre, promised all sorts of things including a champagne supper. When it came to it, we were left with very little time to change into our finery, but everyone, when assembled, looked suitably formal and festive for such an occasion.

The pretty little theatre looked beautiful, and so did the Galitzines – Jean in black velvet and loads of sparkle, her hair done up with a black ruffle, as did their talented and attractive daughter, Katya. She had recently been in Russia filming, playing her great-great-great-great (I think) grandmother, Catherine, whom she is said strongly to resemble. Jean has a photograph of Katya posing in profile against a portrait of Catherine the Great, and the two profiles are the same. How remarkable genetic inheritance is.

It was reassuring to know, as the television cameras (which were everywhere) whirred, that the good-looking Galitzine family were at the front. The theatre itself was also enjoyable to look at, so my thoughts could wander contentedly to the pink marble pillars and red velvet seating of the theatre, and all the wonderful restoration work (which one hoped was well shown on TV), as we listened to a reasonably good violinist playing Bach, watched ballet which compared ill with the Kirov, and listened to a lamentable soprano and a large number of speeches. The champagne supper didn't exactly materialize, which was no surprise. There *was* champagne, but only about two-dozen glasses. Anywhere else but Russia one might suspect this was on purpose, with the champagne for just the select few, but I am sure in this case it was just because nobody had thought of counting the seats and matching them with glasses. So rows of bottles remained untouched on the buffet table. 'Supper' consisted of cakes the size and consistency of bricks for which one

really would have needed a knife and fork. Not surprisingly, most of these, too, remained untouched, though Tony bravely had a try.

A proper dinner would have been welcome. We'd had some hopes of lunch at the hotel when an hors d'œuvre appeared, a little heap of mashed potato and fish which was quite nice, though we had wished each plateful had been larger than a cotton-reel, but never mind, it was just the hors d'œuvre. Our next course had been the water in which the potatoes had been boiled, with a few bits of uncooked potato and a lot of fish bones.

So, when we arrived back from the Hermitage, we roamed the vast hotel looking for something – anything – to eat, but in vain. Luckily we had a few chocolate biscuits left. Next day we discovered that all our party had been in the same fix, but a few – a lucky few – had found a cellar where there appeared to be a party going on. Lashings of caviare and champagne, chicken and ice-cream and cheese, and all sorts of things. Some people were required to pay, and some were not, but all who found it were fed.

For some mysterious reason, for our last lunch at the hotel before going to the airport, we found an amazing spread. Having had, for four days, little more than stale bread and jam for breakfast, we found at each place a tiny triangle of bread with a little caviare on it, and butter in the shape of a heart, and russian salad and potato salad, and then chicken Kiev, and ice-cream with a piece of grapefruit on top. Instead of the dispiriting forest of Pepsi Cola bottles there was Georgian champagne, and none of this was related at all to the repellent fare we had so far faced. Did they only do it at the last moment to show they could? Or did they not dare to give us even one edible thing before in case we expected it again?

Whatever the reason, we had had such a wonderful time, and seen such beautiful palaces and churches, theatre and ballet that it was extremely unimportant.

When we arrived at Gatwick, we learned a very sharp lesson the hard way. *Never* leave your car in an airport car park without

noting exactly where it is. It is not enough to know what your car looks like. All the cars look exactly the same under an igloo of snow. In the dark, starting from one of the bus sheds (but not sure if I had the right one), Tony went one way and I the other scraping the snow off number plates. It was nearly midnight, the rows of cars seemed endless, and it was all deeply depressing. But when we found our car at last, it started at first go, and we drove gratefully out between the long rows of anonymous white igloos, and home to pay our attention to planning our Golden Wedding party.

And, no matter how derisive Andrew was, we did get it all done in time and it was wonderful. We had in fact two parties, because we both have such large families that they made one party, a hundred of them, and the other party was for all the friends who aren't relations as well.

One grandson, aged about eight at the time, was deeply impressed by how the house and marquee looked.

'Just look at all this,' he said to me. 'All this gold. Gold balloons and gold ribbons, Grandfather's gold waistcoat and your gold jacket and shoes – if I didn't know better I'd think this was a rich family!'

Many a true word . . .

Also from Rosemary Trollope

STARTING FROM
GLASGOW

FOREWORD BY JOANNA TROLLOPE

From these vivid word pictures of her own and her mother's Glasgow childhood, Rosemary Trollope roams across places and generations, capturing with an artist's eye the detail and atmosphere of her own time, and her family's life before she was born.

The grandparental Glasgow house was the steadfast rock, the house where she and her brothers and sister were all born, and whence the family fled for refuge on the sinister night when it was discovered that a deranged cook was trying to kill the children with arsenic. Fortunately they survived, and were able to go on and enjoy all the pleasures Glasgow had to offer, with the Kelvingrove Art Galleries, and all its riches and variety, high on the list.

Later came a move to rural Herefordshire, but for Rosemary there was always a loyalty to Glasgow as she returned there to the School of Art. Her drawings and the cover painting complement this entertaining, and sometimes touching, book.

'Rosemary Trollope is a born writer'
Hampshire Chronicle

ISBN 0-7509-1784-9